Creative
Exposure Control

Creative
Exposure Control

HOW TO GET THE EXPOSURE YOU WANT EVERY TIME

Les Meehan

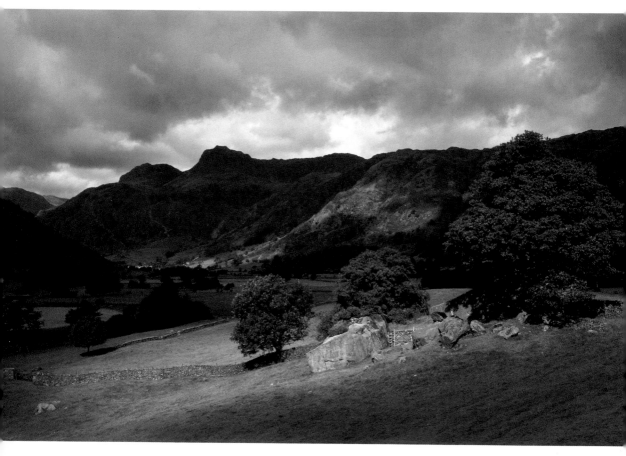

COLLINS & BROWN

First published in Great Britain in 2001 by
Collins & Brown Limited
64 Brewery Road
London N7 9NT

A member of **Chrysalis** Books plc

3 5 7 9 8 6 4 2

British Library Cataloguing-in-Publication Data: A catalogue
record for this book is available from the British Library.

ISBN 1 84340 049 9

Editorial Director: Sarah Hoggett
Senior Editor: Clare Churly
Editor: Ian Kearey
Design: Amzie Viladot, Design for Publishing

Reproduction by Classicscan, Singapore
Printed and bound by C&C Offset in China

This book was typeset using Gill Sans

Contents

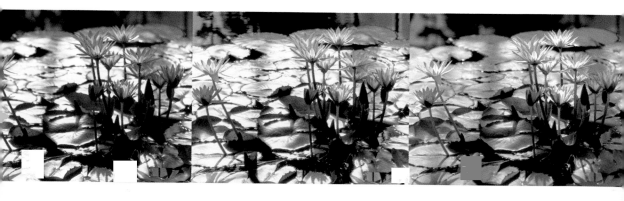

Introduction

What is exposure?

To produce outstanding imagery, the creative photographer requires a wide variety of skills. It is not enough simply to buy the latest, gadget-packed 35mm SLR, nor is it ideal to do so, as this book will show. All visual media require the practitioner to develop competence in two essential areas: visual awareness and craft.

An essential aspect of the craft of photography is exposure control. Many people find this aspect of photography difficult to master. This is generally due to a lack of knowledge of the factors affecting exposure determination, and reliance upon technology to provide all the answers. As will be seen, the technology is sadly lacking in several key areas.

This book looks at the most important practical aspects of exposure control, and how those factors can be controlled and manipulated for creative results. Whenever possible, I will approach the subject from a practical, rather than theoretical, viewpoint.

The term "exposure" is given different meanings by photographers, depending upon the context in which it is used. For the purpose of this book, let's start by defining what exposure is in practical terms.

Photographic exposure specifically refers to the effect of light on a photographic emulsion. How much the emulsion is affected is directly related to the total quantity of light received. The total amount of light allowed to act on the emulsion is controlled in a camera by the aperture and shutter speed settings.

Mastering the craft of photography involves learning about the materials and techniques necessary to produce excellent quality work. Without this knowledge it is impossible to fully capture your response to a subject in the image. Once the craft has been learned it is then possible to develop your visual skills to heighten your ability to "see" with the artist's inner eye.

A vital point to grasp is that creativity relies directly on craft skills. Without craft skills, your creative development will be doomed to disappointment. Having good ideas is one thing, creating the image that fulfils those ideas is quite another. Mastering exposure control is a vital first step in this process.

▶ **Exposure for emphasis**
A knowledge of exposure control, and the practical methods explored in this book, will allow you to create your desired image under any subject conditions. Here, exposure based on the bright areas combined with a polarizing filter emphasizes the design of the windows.

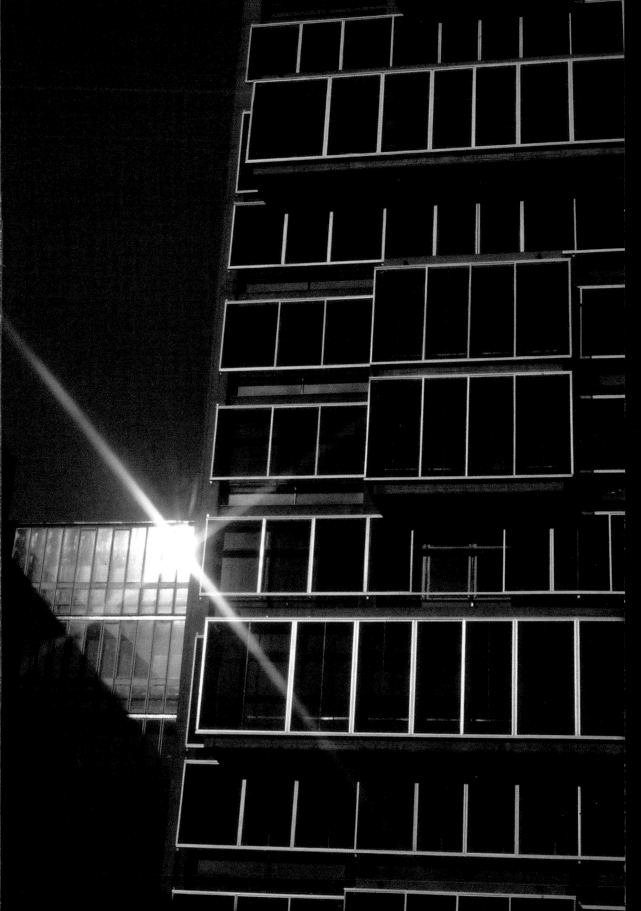

Why we need to understand exposure

Many people believe that owning the latest automatic camera will solve all their technical problems and produce creative results. Unfortunately, this is not the case. Even the most sophisticated auto-metering system can only handle a limited range of the possibilities likely to be encountered in creative work.

To be able to accurately determine the desired exposure for any subject, it is vital to have a sound grasp of all the factors that might influence that exposure. It is also important to adopt a logical approach to using and interpreting the information your light meter provides.

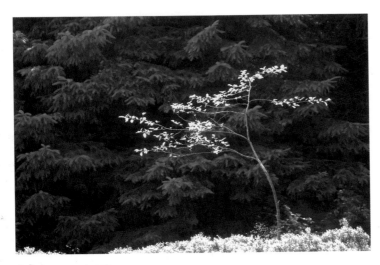

 Lower contrast

This scene has a large area of dark tones that will fool automatic-exposure cameras into overexposing the image. This results in a loss of color saturation and contrast. In this case, the image has lost the sharp mood of the scene.

▶ **High contrast**
The desired image is obtained. The high-contrast scene has been exposed to retain the impact of the light green against the dark foliage.

Fully automatic metering systems in modern cameras are a triumph of technology, and can perform well under certain circumstances. However, a creative photographer is likely to explore a wide variety of subjects in unusual conditions in the search for stimulating pictures. Relying on the automatic systems to make what are creative decisions regarding exposure will more often than not result in an image that doesn't reflect your interpretation of the subject. The image shown here is a classic example of such a scene. High contrast subjects like this present the greatest challenge for exposure assessment.

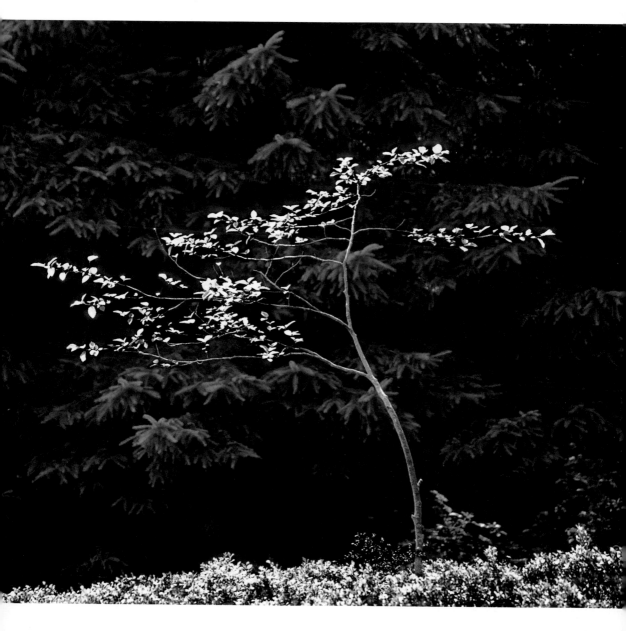

1 Factors influencing exposure

In principle, achieving the desired exposure for a subject should be a straightforward task. There are numerous light meters available to assist the photographer, ranging from the simplest, that can only do a single incident reading, to highly sophisticated models capable of recording several readings from both flash and ambient light. Why then, with all this technology available, do so many people lack confidence when dealing with exposure determination?

Having a light meter available is one part in achieving the desired exposure for a given subject; however, the factors influencing exposure go beyond the light meter alone. We need to explore topics such as filters, magnification, lighting, film, and more.

Shutter and aperture relationship

The two camera controls that regulate the amount of light reaching the film – and hence the amount of exposure the film receives – are the shutter and aperture.

The shutter speeds control the time the light is allowed to act on the film, while the aperture, or f/stop, determines the amount of light passing through the lens. The desired exposure, determined from meter readings and your interpretation of the subject, is achieved by setting one combination of shutter speed and aperture.

Changing the shutter speed or aperture by one full stop either doubles or halves the amount of light reaching the film. Making the shutter speeds slower or faster respectively increases or reduces the amount of light hitting the film. Apertures represent fractions (i.e. focal length of lens divided by the diameter of the aperture hole), so the higher the f/stop the less light allowed through the lens. For example, an aperture of f/8 allows twice as much light to pass than f/11. The creative possibilities of shutter speeds and apertures, subject motion, and sharpness are explored on pages 80–81.

Understanding the relationship between these two controls is vital. Whenever you change only the shutter speed or the aperture on the camera, you are changing the exposure the film receives. Remember that if you want to change either of these controls but retain the same overall exposure on the film, you need to change both settings by the same relative amount.

Changing shutter and aperture correctly

This sequence shows that you can obtain the same exposure for a subject using different combinations of aperture and shutter speed. Movement and depth of field dictate the settings used.

▲ Fast shutter speed, wide aperture
The exposure for this image (½₅₀th second at f/4) was determined using the light meter. This produced the desired exposure, but the depth of field is very narrow, resulting in a loss of sharpness in the middle and far distance.

▲ Medium shutter speed, medium aperture
I reduced the aperture to f/11 to give more depth of field. This reduced the amount of light reaching the film. To get the same exposure as in the first frame, I needed to use a longer shutter speed. Because I had reduced the aperture by three stops (from f/4 to f/11), I needed to lengthen the shutter speed by three stops (from ½₅₀th second to ⅓₀th second).

▲ Small aperture, slow shutter speed
To increase the depth of field even more, I closed the aperture by another two stops (to f/22) and therefore had to lengthen the shutter speed by a further two stops, to ⅛th second. This resulted in the same amount of light reaching the film, but again created a different visual effect.

Changing shutter speed only

This sequence shows how changing only the shutter speed results in a change to the amount of light that reaches the film. To keep the same exposure, adjust both controls!

▲ **Correct shutter speed for aperture setting**

This image is the desired exposure. The scene was metered correctly, and the required combination of aperture and shutter speed was set. In this example, the depth of field was important, and so a small aperture, f/22, was selected.

▲ **Shutter speed too fast for aperture setting**

This is what happens to the tones when less exposure is given. Again, f/22 was used but the shutter speed setting was too fast, resulting in underexposure. All the tones are darkened. The darkest tones lose their detail, while the lighter tones become too dark.

▲ **Shutter speed too slow for aperture setting**

The same f/22 aperture was used, this time with a too-slow shutter speed. The result is overexposure – too much light reaching the film. All the tones become lighter, and the colors are less saturated, resulting in a "washed-out" look.

PRACTICAL TASK

To more fully understand the relationship between shutter speeds and apertures, try this exercise:

1 Choose a subject to photograph.

2 Set the shutter speed to ¹⁄₂₅₀th second. If your camera is not fully manual, and does not have shutter priority, select aperture priority and set f/8.

3 Meter the subject so that the camera tells you which aperture to use (or shutter speed on an aperture-priority camera).

4 Set the aperture (or shutter speed) and make one exposure. Make a note of this shutter speed/aperture combination.

5 Change the shutter speed by one stop, and adjust the aperture by one stop to obtain the same exposure. Do this without checking the light meter.

6 Make a second exposure. When you process the film, the exposure of both frames should be the same.

Standard scales

Shutter speeds and aperture values always follow the same sequence as shown in the table. The light meter will indicate the pairs of values that will produce a particular exposure, e.g. ¹⁄₂₅₀th second at f/16 produces the same amount of exposure as ¹⁄₃₀th second at f/8.

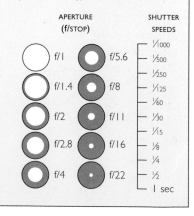

APERTURE (f/STOP)		SHUTTER SPEEDS
f/1	f/5.6	¹⁄₁₀₀₀
f/1.4	f/8	¹⁄₅₀₀
f/2	f/11	¹⁄₂₅₀
f/2.8	f/16	¹⁄₁₂₅
f/4	f/22	¹⁄₆₀
		¹⁄₃₀
		¹⁄₁₅
		¹⁄₈
		¹⁄₄
		¹⁄₂
		1 sec

Film Speed

Film speed is an indication of how sensitive an emulsion is to light. Every batch of film is tested under controlled conditions and given an International Standards Organization speed rating by the manufacturer. This nominal speed is then indicated on the packaging by an ISO number.

In everyday use we tend to refer to film speed as fast, medium, or slow. Film speeds above ISO 400 are "fast" films (high sensitivity to light) because they require less light to form an image. Films between ISO 200 and ISO 64 are medium speed, and those of ISO 50 and below are considered slow films.

In this speed system ISO 200 is twice as fast as ISO 100, ISO 50 is half the speed of ISO 100. Relating this to f/stops, ISO 200 film is one stop faster than ISO 100 film. In practice, photographing the same subject on both ISO 100 and ISO 200 film under the same conditions would require one stop less exposure for the ISO 200 film.

It is important to understand that the speed given to a particular film by the manufacturer is only a recommended speed. It is not necessarily the speed that will give you the results you want.

▼ **Slow film: ISO 64**
Slow film is ideal for finely detailed subjects and maximum color rendition. In this image, the strong color saturation helps to isolate the leaf against the dark background.

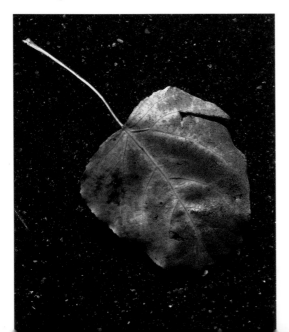

Using different speeds of film

We can generalize about the visual qualities of film speed as shown here. This sequence was photographed on three different films with different film speed.

Using Ilford Pan F at ISO 50 produces excellent sharpness and fine grain. These qualities enhance the fine detail and smooth tones of the subject. The second image uses Kodak ISO 400 Tri-X film rated at my calibrated speed of ISO 160. Here, the grain is more pronounced, making the tones gritty, and the details have less clarity. Using Fuji Neopan 1600 film calibrated to be ISO 500, the grain and loss of detail are more evident, and the mood of the image is softer than on the other films.

◀ **Slow film**
Ilford Pan F (ISO 50) produces excellent sharpness and fine grain. These qualities enhance the fine detail of the subject.

◀ **Medium-speed film**
Kodak Tri-X (normally rated at ISO 400 although processed here to achieve a rating of ISO 160) gives pronounced grain and the detail in the subject has less clarity.

◀ **Fast film**
Fuji Neopan 1600 (normally rated at ISO 1600 but here processed at ISO 500) produces the most grain and the least detail.

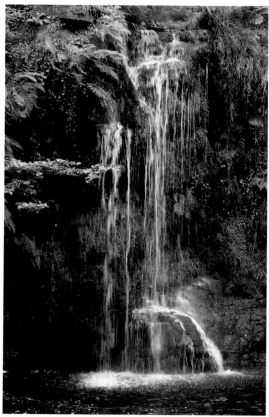

▲ **Medium-speed film: ISO 400 rated at ISO 250**
Films with speeds between ISO 100 and ISO 400 are a
good choice for general subjects that have a wide range of
tones. They have reasonable sharpness and color rendition
that is ideal for subjects where a literal interpretation is
desired. The film used was Fuji Provia 400.

▲ **Fast film: ISO 1600 rated at ISO 500**
These wind props were shot on fast grainy film to
create a surreal mood, enhanced by the use of a red
filter to darken the sky.

PRACTICAL TASK

This task allows you to explore
how different film speeds affect
the mood and detail of a
subject. With color film, color
rendition can be examined.

1 Choose three subjects
with different characteristics,
e.g. a finely detailed subject,
another composed of smooth,
colored surfaces, and a portrait.
Photograph each on three

different film speeds, e.g. ISOs
50, 200, and 1000.

2 Once processed, group the
images by subject. You
should have at least three
photographs of each subject.

3 Examine each image
carefully in terms of
sharpness, contrast, detail, and
color rendition.

4 Make a mental note of
which film speed you like
best for each type of subject.
This will be a personal choice,
based on your visual
preferences, that will help you
when producing future work.

Film contrast range

The contrast range of a film is an indication of the range of subject brightness values (see pages 24–25) that can be recorded with detail during one exposure using normal film development. Surprisingly, this detail range is quite limited.

The film contrast range is expressed as a ratio of the lightest and darkest important subject brightness values that can be recorded in the image. This ratio can be written either numerically or in terms of stops (remember, a one-stop change is a doubling or halving of the exposure). A typical contrast range often quoted for film is 128:1 or 7 stops. This means the lightest area of the subject is 128 times brighter than the darkest area.

A subject brightness range of 7 stops is recorded on the film in tones from nearly featureless black to almost blank white. In the zone system this would be from zone 2 to zone 9 (see pages 54–55). However, this is not the range of tones that will actually record good subject detail in the image. For the majority of film types a contrast range of 32:1 or 5 stops is more practical when good subject detail is required.

For creative control, you should carefully test each brand and speed of film you want to use, to determine the practical contrast range it can record. This once-only test will show you exactly how a particular film records detail at different exposure levels.

PRACTICAL TASK

To determine the effective contrast range of a film, conduct the following experiment:

1 Select a gently textured surface in flat lighting. Meter the subject and expose one frame.

2 Make a series of five more exposures, increasing the exposure by one stop for each frame.

3 Meter the subject again and make another series of five exposures, but this time reduce the exposure by one stop each frame. The result will be eleven frames, each differing by one stop from the previous frame.

4 Examine the first frame and note the detail. Then examine each of the other frames and count those frames that show any detail. This will tell you the contrast range of the film.

If you want to make this test more precise, change the exposure for each frame in half-stop increments. This would require a total of 21 frames. For transparency film, simply view the images directly. With black-and-white film, make a contact print on normal paper and examine the frames on the contact.

◀ **Within the contrast range**
In this simple image, the subject easily fits within the contrast range of the film, and detail and texture are present throughout the subject.

▶ **Full contrast range**
A subject such as this uses the full contrast range of the film. It is only in the deepest shadows that detail has been lost.

Film color response

General-purpose films are designed to respond to the colors of a subject so that the picture produced will look natural. A film's response to different colors is known as the spectral sensitivity or, more simply, color response. Film is normally color-balanced for use in either daylight or artificial light.

For a film to record a scene so the colors look natural, the color response has to be "panchromatic," that is, to have an almost equal response to red, green, and blue, the primary colors of light.

You need to be familiar with the general color response of the film you are using so that you can anticipate how it will respond to colors and make adjustments, if necessary, to achieve the result you want. Also, knowing how a particular film records color at different brightness levels will allow decisive visualization of any subject.

You can alter the color response of the film by using color filters (see pages 30–31). A classic example in black-and-white landscape would be using a color-contrast filter to darken a blue sky.

PRACTICAL TASK

To determine how a film records color, try the following:

1 Arrange some brightly colored objects in sunshine, e.g. children's building blocks. Aim to have at least red, green, and blue colors. It is also useful to include a Kodak gray card.

2 Make a normal exposure. Meter off the gray card.

3 Make four more exposures, reducing the exposure by one stop each time.

4 Return to the normal exposure, and make four more exposures by increasing the exposure one stop each time.

5 Process the film and carefully examine each

image to learn how the film records the colors.

Compare the image to the original subject.

If you included a gray card, check the normal exposure to see if the gray is neutral in color. Be aware that color perception is a very personal issue and no two people will entirely agree.

◄ **Accurate colors**
Knowing that red records well at lower-than-normal exposure levels, I was able to reduce the exposure to make the background weathered wood dark while enhancing the visual impact of the bright red.

▲ **Heavy color cast**
Using daylight-balanced film in artificial lighting distorts the color response, resulting in a heavy color cast. In this type of scene, the false color is not a problem, but it could have been reduced with a suitable bluish filter.

Lighting contrast

Creating a photograph that looks the way you want it to look is an exercise in controlling contrast at various stages of the process. One of the factors to consider is lighting contrast. Lighting contrast is generally defined to be the difference between the quantity of light striking a subject directly, and that reaching the shadows.

When the direct light on a subject is considerably more than the shadow illumination (shadows are indirectly illuminated by light reflected from other areas of the scene), the lighting contrast is said to be high. Out of doors, the lighting contrast can often be too high to record the required detail in the subject.

When similar amounts of light illuminate most of the subject, the lighting contrast is said to be low or flat. In this case, it is generally easy to retain detail throughout the subject.

Lighting contrast is one of the most important aspects to consider when assessing a new subject. Assessing lighting contrast requires good knowledge and accurate use of your light meter (see pages 36–37).

◀ **Low contrast**
This is a low-contrast lighting situation. Note how the colors are muted by the haze.

PRACTICAL TASK

To appreciate how lighting contrast affects the image of a subject, try the following:

1 Choose a subject out of doors that you can return to easily, and select a viewpoint that you find interesting. Try to select something that is not close to reflecting walls, such as a statue in a garden. Reflections from nearby objects will reduce the lighting contrast too much.

2 Photograph the subject on medium-speed film (ISO 100) under bright, sunny lighting conditions, with the sun to one side and slightly behind you.

3 Photograph the same subject from the same position under various lighting conditions. Use at least three different situations, i.e. bright sun no clouds, sun with white clouds, and overcast conditions.

These three conditions should provide lighting of high, normal, and low contrast. Once you have the photographs, examine them carefully and study the differences that each type of lighting contrast has on the subject. Note particularly how light or dark the shadows are compared to the directly illuminated parts, and how easy it is to see details in those areas.

▲ Normal contrast
With normal-contrast lighting, the subject has good detail in the important areas, and the color is natural.

▶ High contrast
High-contrast lighting produces dark shadows with little detail. As shown here, this lighting can also produce dramatic textures.

Lighting ratios

Lighting ratios are one way of expressing lighting contrast in terms understood by photographers.

For quick assessment, the lighting contrast can be measured by taking two meter readings in order to convert it to a lighting ratio. The lighting ratio is the difference between a reading of the direct light on the subject and a reading of the light illuminating the shadow areas. This difference is expressed as a ratio of units of light. Once you are familiar with establishing lighting ratios, setting up the lighting for shots becomes quicker, particularly in portraiture or model work, where time may be limited.

A lighting ratio of 3:1 means that one unit of light is reaching all parts of the subject and an extra two units of light are reaching the bright areas. In terms of stops, the bright areas are receiving exactly one stop more light than the shadows. If the shadow reading was f/8 and a ratio of 3:1 is required, the direct light reading needs to be f/11, one stop more. For a 4:1 ratio the direct reading must be f/16.

With an incident light meter, accurately assessed lighting ratios can help you decide how the subject will look in the final image. In many cases, adopting an exposure midway between the two meter readings will produce an acceptable exposure, but this method is no substitute for the reflected reading method (see pages 42–43).

Conversion table

Difference in f/stops	Lighting ratio $(2^{\text{diff in stops}} + 1)$
½	2.5:1
1	3:1 (Low contrast)
1½	3.8:1
2	5:1 (Normal contrast)
2½	6.7:1
3	9:1 (High contrast)

Changing lighting ratios

This close-up sequence of a head shows how different lighting ratios affect the mood of a portrait. Lighting was from one studio flash fitted with a small white umbrella to slightly soften the shadow edges. The light in the shadows was controlled with a reflector at various distances.

▲ **High ratio**
High lighting ratios of 6:1 or more produce dark shadows with little detail when the directly lit side is exposed correctly. High lighting ratios can impart a dramatic mood to the subject.

▲ **Normal ratio**
Medium or normal lighting ratios of around 4:1 or 5:1 tend to show good detail in the low and high tone values of the subject. This level of lighting ratio will record a subject well on most general-purpose films.

▲ **Low ratio**
Low lighting ratios of 2:1 or 3:1 produce shadows that seem full of light. The overall mood of the subject is gentler than with high ratios.

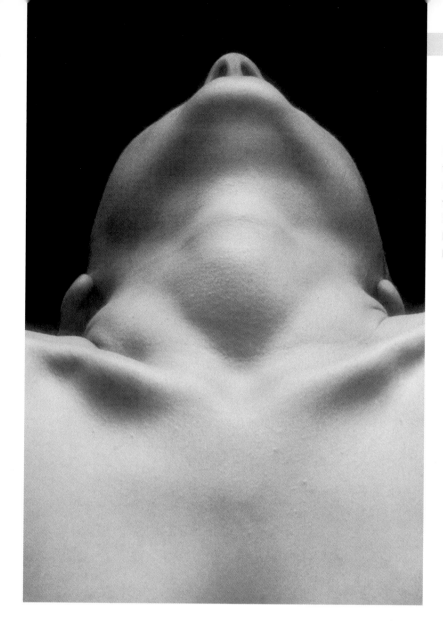

◀ **Dramatic ratio**

In this abstract image of a female neck, I wanted to emphasize the shape of the bones and muscles, so I opted to use soft-edged lighting but with a dramatic lighting ratio of 5:1.

PRACTICAL TASK

To explore the concept of lighting ratios for yourself, try the following task:

1 Place a cardboard box on a table in the middle of a room (to avoid unwanted reflections from walls). Darken the room as much as possible (ideally do this task at night). Position the box so you are looking at one edge and can see two sides equally.

2 Place a direct light source so it lights only one side of the box from about 2 feet (60 cm) away. This will produce a high contrast ratio.

3 If you are using an incident meter, place it near the lit side of the box, pointing at the light. With reflected light or TTL meters, meter the lit side of the box only. Note the reading.

4 Take a second reading. If you are using an incident meter, place it in the shadow and close to the box and point towards the camera. With a reflected light or TTL meter, meter the dark side of the box. Make a note of this new reading.

5 Compare the difference in f/stops between the two readings. To convert this to a lighting ratio, see the table (left).

6 Now experiment by reflecting light into the dark side of the box, using white card to alter the lighting contrast. Use the light meter to achieve specific lighting ratios e.g. 2:1, 5:1, etc.

Subject brightness range

For an object to be visible to the human eye, it must reflect light. How much light an object reflects determines how light or dark it appears. Every subject or scene you photograph will be composed of various brightness values, because the objects in the scene will reflect different amounts of light.

The difference between the lightest and darkest brightness values of a subject is known as the subject brightness range (SBR). The SBR is measured with a light meter and can be specified in f/stops. When determining the SBR of a scene, you only need to use the range of brightness values that are required for your desired image. You do not need to use the absolute extremes of light and dark unless they are part of your image visualization.

Determining the SBR of a scene accurately is the single most important requirement for achieving accurate exposure: it determines not only the camera settings, but also the development necessary to achieve your desired interpretation of the scene. A practical method of assessing SBR is given on page 64.

◀ **High SBR**
With high-SBR scenes you need to decide whether to retain detail in light areas, as here, or to sacrifice this for shadow detail. When using transparency film, it is visually more acceptable for shadows to lack detail than for high values to become total white.

▶ **Full tonal range**
With bright sunshine lighting this subject from the side, a full tonal range is created. This will use all the available detail the film can provide with normal development, and accurate exposure is crucial.

▶ Low SBR

Low-SBR subjects appear low in contrast and usually reveal good detail in all areas. This often requires increased development to improve the image contrast. However, in this case the visual contrast created by the white stone meant normal development was acceptable.

Intensity of illumination

Intensity of illumination refers to the quantity of light falling on a subject. The illumination reaching the subject, combined with the subject's surface properties, will determine how much light is reflected from the subject to the camera. This can have important consequences both creatively and technically, and will influence the options available at the film exposure stage.

Higher levels of illumination, i.e. bright, sunny weather, permit a greater range of choice for such things as film speed, aperture and shutter speed combinations, freezing movement, or using greater depth of field.

Low levels of illumination restrict your choices in the creative aspects of image management. For example, it would be very difficult to freeze the movement of cars or people in a street scene at night, because the low illumination may dictate a long exposure time with the desired f/stop.

Compromises will inevitably have to be made when deciding how you want to interpret scenes with either high or low levels of illumination.

Law of reciprocity

When photographing in situations that require shutter speeds longer than 1 second, the normal exposure relationship — that closing the aperture one stop can be compensated for by doubling the shutter time — doesn't actually work. The reason for this is in the way the light-sensitive emulsion reacts to low levels of light. The practical effect is that long exposure times

▼ **Low light**

This image was created using medium-speed film in very low light conditions. The metered exposure was 16 minutes at f/64. Applying correction for magnification and reciprocity produced a final exposure time of 1 hour 20 minutes.

actually produce less exposure than anticipated. If you plan to do a lot of photography involving long exposure times, it is better to use type L film (better known as tungsten film), specifically made for long exposures.

As an example (assuming normal daylight film), let's say that the meter indicates an exposure of 2 seconds at f/8, but you want to use f/22. Normally, you would simply adjust the time to 16 seconds to compensate. However, this new time would probably produce an underexposed image. This breakdown of the normal rules is known as reciprocity law failure.

A further factor is that reciprocity failure reduces the shadows more than the light parts of the image, resulting in an increase in the image contrast. It is usually necessary to reduce the film development to compensate for this increase.

In color, an additional side-effect of reciprocity failure is color shifts. These are caused because the various layers of the emulsion do not react identically to the problem.

Reciprocity correction – in stops

Film	1 Sec	4 Sec	8 Sec	16 Sec	1 Min
Fuji Velvia	0	0	$+\frac{1}{2}$	$+\frac{2}{3}$	$+1\frac{1}{3}$
Fujichrome 100	0	0	$+\frac{1}{3}$	$+\frac{2}{3}$	$+2\frac{2}{3}$
Kodachrome 25	$+\frac{1}{2}$	$+1$	$+1\frac{1}{2}$	2	$+3\frac{1}{2}$
Kodachrome 64	$+1$	$+1\frac{1}{2}$	$+2$	$+2\frac{1}{2}$	$+3\frac{2}{3}$

PRACTICAL TASK

A reciprocity correction table can be created by testing a film in low light conditions with a sequence of exposure times. A useful sequence of starting times would be 2, 8, 16, 32, and 64 seconds. For times greater than 2 seconds, use the camera on T or B and a clock to count the seconds.

1 Using a piece of gray card in normal conditions as a target, meter the card and make a reference exposure with a shutter speed around $\frac{1}{125}$ second. Set the aperture to whatever the meter indicates.

2 Place the same card in a low light situation and meter it. Adjust the exposure settings to use a shutter speed of 2 seconds, and expose one frame. Now expose 2 more frames, increasing the exposure time to 3 seconds and 5 seconds respectively to compensate for any reciprocity failure.

3 Now close down the aperture until your meter indicates an exposure time of 8 seconds. Expose one frame at 8 seconds. Expose three more frames using 11, 16, and 22 seconds. These times are in half-stop increments. Repeat this method starting with 16 seconds, then 32 seconds, and so on (you may have to reduce the lighting on the card).

4 As the initial exposure time gets longer, the reciprocity failure increases dramatically. Therefore, the longer the starting time, the greater the correction needed, so use bigger steps on the additional frames.

5 Process the film and compare the sequences against the first reference frame shot in normal conditions. Look for the frame from each sequence that matches the reference frame, and note both the starting time and the corrected time for that sequence. Also note any color shift that has appeared. This could be corrected with the appropriate filter on the lens. The information from this task will allow you to make a correction table to use in the future for that film. You will need to test each film you use in color and black and white.

Development and image contrast

Once a film has been exposed, it must be chemically developed to produce a visible image. Exposure and development are linked in the creation of the desired image.

When the film is exposed, the light-sensitive crystals (halides) absorb some of the energy from the light striking them. The more exposure the film receives, the more change takes place. Therefore, light areas of the subject have more effect on the film during exposure than dark areas.

Making an exposure in the camera produces a latent image on the film. When the film is developed, the invisible latent image is converted into a visible image made of black metallic silver. The amount of silver produced is directly related to how much exposure each area of the film has received, and how much development is given. Therefore, film development directly affects the image contrast produced on the negative or transparency. Development control is an important creative

▼ **Long SBR**
In this scene I wanted to retain the subtle tonal differences in the reeds on the water, but the scene overall had a high SBR. By exposing for the rocks and reducing development, a good tonal range was achieved in the final picture.

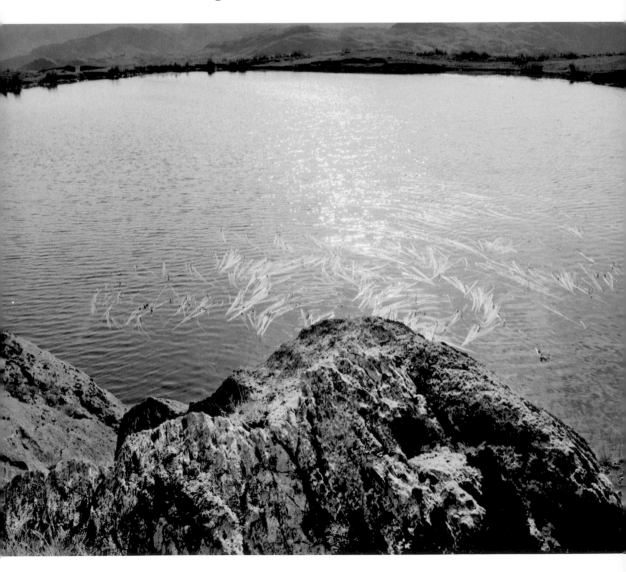

tool, both in color and black-and-white work (see pages 122–123).

The essential concept to understand is that accurate exposure can only be achieved if the development of the film is correct for both the film being used and the way the subject is being interpreted.

Even with the correct exposure, if the film development is too little, the tonal value of the lighter areas of the subject will be darker than you had anticipated. Conversely, if too much development is given the subject's lighter areas will be too bright and may lose detail.

▲ **Different development times**
This sequence clearly shows how development affects the lighter tones more than the dark tones. The subject contains three brightness values. The brightness of the dark area is two stops less (zone III) than the center, which is middle gray (zone V). Zone values are defined on pages 54–55. The lightest area is white and is three stops lighter (zone VIII) than the center. Each sample was exposed identically but then given different development. The development was increased by 30 percent each time, starting at 4 minutes. The third sample received correct development at 6½ minutes. It is clear that image contrast increases as the development time gets longer.

▶ **Increased development**
This abstract of a stack of plastic chairs was created with a combination of accurate exposure and development control to achieve the strong image contrast without losing subtle tonal values. I exposed the shadows for minimal detail, but then increased development to raise the high values by one stop so the plastic would still look white.

Filters

Photographic filters are used to control how the colors in a scene are recorded on the film. Color-compensating filters are used to alter the image on color film, either to correct a color cast or to create a specific color mood for the scene. In monochrome, color-contrast filters are used to modify the tonal rendition of a scene.

All colored filters transmit some colors and block others. In monochrome, for example, a yellow contrast filter blocks blue light and transmits red and green light. Monochrome contrast filters lighten their own and similar colors, and darken their complementary color.

Most filters absorb some light, which reduces the exposure. The exposure correction suggested for a filter is referred to as the filter factor. However, the actual amount of light a filter absorbs, and therefore the filter factor required, changes as the color of the original light changes (daylight continually changes in color from dawn to dusk). Because the manufacturers' filter factors are based on a fixed color of light, known as "standard daylight," they are not reliable under other circumstances. For example, at sunset the light contains lots of red, hence a red filter will not absorb much light, so the filter factor will be less than at noon, when the light contains lots of blue (which the red filter blocks).

The best method of dealing with filter light loss is to meter directly through the filter. This method takes into account the color of the light on the subject at the time of exposure by measuring the actual light passing through the filter. However, a greater advantage of this method is that it allows you to determine exactly how the filter is modifying the image tones. This dramatically helps your visualization and control of the image.

To check how a filter affects a subject, meter two colored areas in the subject without using a filter and note the difference between the readings. Next, meter the same areas through a filter, and again note the difference in readings. Any change in the difference between the unfiltered and filtered readings tells you what the effect of the filter has been. A typical example would be a landscape with blue sky and white clouds. Metering the clouds and blue sky may show a difference of, say, two stops. However, you may want a more dramatic effect so you want to use a filter that darkens blue — but which one? Simply metering the sky and clouds through each filter and comparing the difference in stops will tell you exactly what each filter is doing to the sky. You can then make an informed choice about what filter will produce the effect you want in the image (see pages 38-39).

PRACTICAL TASK

To understand how different filters affect the colors in a scene, try the following:

1 Choose some different colored objects and a white and a black object.

2 Arrange the objects together and photograph them on monochrome film. This is your master image that shows how your particular film handles the colors.

3 Now photograph the group using each contrast filter you have. Include the name of

the filter on paper in the scene so you know which filter was used.

4 Print each negative so that the white object has the same white tone in the print, and examine how the colors have been modified by each filter.

For color film, use a selection of warming and cooling filters. Don't use the strong filters used for monochrome unless you just want a dominant color cast.

▶ Spices color

This image shows the original colors of the subject. You can see that the monochrome image that has been modified with a yellow filter is the closest match tonally.

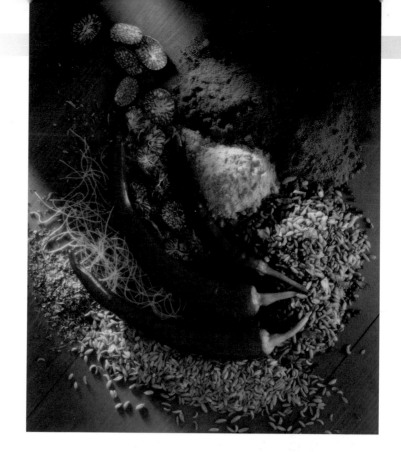

▶ Spices monochrome

This is how the subject appears in tones of gray using contrast filters on the camera. The unfiltered image can be considered the realistic rendition. The other images show the tonal changes using yellow, orange, red, and green filters respectively. Refer to the color image and unfiltered version to examine how the colors have been altered in each case.

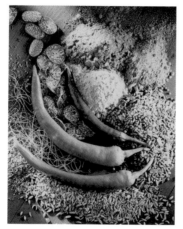

Unfiltered

Yellow filter

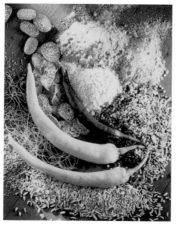

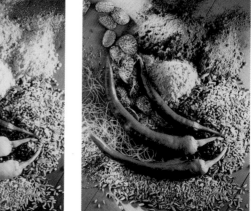

Orange filter

Red filter

Green filter

Magnification factor

Magnification refers to how big the image of an object is on the film compared to the size of the original object. For those photographers who never work closer than 10 focal lengths distance from the subject – for example, 3 feet (1 meter) with a 100mm lens – magnification is not important because it doesn't significantly affect the exposure required.

As you focus closer to a subject, the distance between lens and film increases. This increases the image size and hence the magnification.

Unfortunately, moving the lens away from the film also reduces the intensity of light reaching the film. If this loss of intensity is not compensated for by adjusting the exposure, the result will be an underexposed image.

Because a TTL meter measures the actual light passing through the lens, the loss of light due to the lens extension will be corrected when you take light readings. With separate meters, you must correct for the magnification when working close to the subject.

PRACTICAL TASK

If you use a separate light meter, you can work out the amount of exposure correction you need by using the following simple two-step method. As an example, assume we are photographing a coin that is 30 mm in diameter. It is easiest to use metric units.

Find the magnification factor

1 Measure the actual coin in the scene and note its size. You can measure any part of the scene, but use the same part in step 2.

2 Next, measure the image of the coin on the camera screen, or use the viewfinder image to estimate the size. Note this image size, e.g. the coin is 15 mm through camera.

3 Now divide the image size by the actual size, e.g. $^{15}/_{30}$ = 0.5. This is the magnification factor (M=$^{Image}/_{Object}$).

Find the exposure factor

4 Add 1 (one) to the magnification factor, i.e. (M+1) = 1½ and square this number (1½ times 1½ = 2.25). This is the exposure factor (x2.25 or +1¼ stops) you require to correct the metered exposure. Once the exposure for the subject has been determined simply increase this exposure by the exposure factor to arrive at the final corrected exposure.

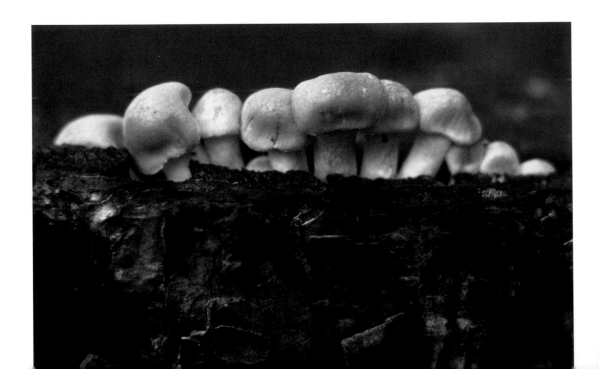

◄ TTL meter

Out of doors, a TTL meter will compensate for magnification without problems, so no calculations are required. However, careful metering is needed. Here I used center-weighted TTL metering to take a reading from the dark wood. I needed to reduce this exposure by 1½ stops to avoid overexposing the fungi.

▲ Hand-held meter

Because this image was lit by flash, a hand-held meter was used to determine exposure. The image was the same size as the actual flower so the magnification was M = 1. Therefore, the exposure was increased by a factor of x 4 (two stops).

2 Exposure assessment

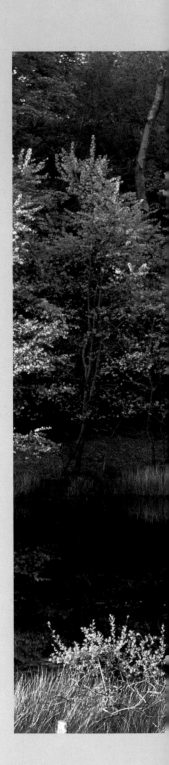

Correct exposure assessment relies on several factors. The most important of which is being able to visualize the image you wish to create before you press the shutter. Even with expert knowledge of exposure control, incorrect visualization may result in a disappointing image.

This section explores the various tools and methods that need to be understood to assess exposure accurately. It also explores a practical method of creative image visualization developed by Ansel Adams and Fred Archer. This practical and easy-to-learn method provides an intuitive approach to exposure assessment for any subject under all conditions, whether using color or black-and-white film.

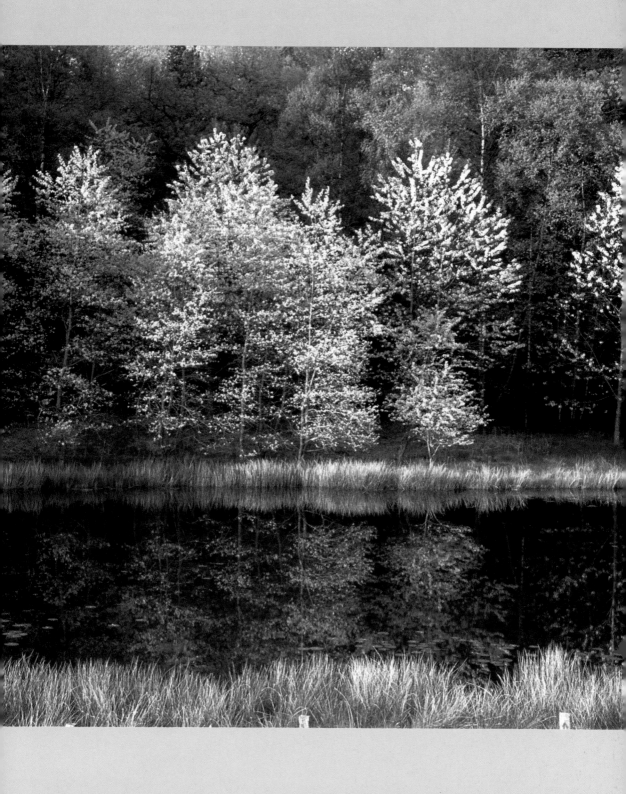

Light meter calibration

Light meters are calibrated by the manufacturers using their own standards. Although there is an international standard controlling calibration, different light meters will often display different results when measuring the same subject.

For your light meter to be accurate, you need to calibrate it for the film and processing you intend to use. A simple film test (see right) establishes your personal film speed for a particular film/processing combination. This test takes into account all the variables, including your own working methods. You must test each film you use; in monochrome, test each film/developer combination you use.

Most photographers calibrate their meters using a Kodak gray card that reflects 18 percent of the illumination and is universally known as middle gray. Once the meter has been calibrated, metering any subject will produce exposure settings that will make that subject a middle gray tone in the image. This is a crucial reference point for controlling exposure.

▼ Metering water
Subjects with extreme brightness ranges require careful measurement with a meter of the light and dark areas. Here, accurate exposure was obtained by increasing the meter's recommended exposure for the brightest water by three stops. However, this will only be accurate if your meter has been calibrated.

▲ Metering backlighting
Having confidence in your meter allows you to visualize exactly how light or dark you want a subject to be. For this backlit leaf, I wanted to retain the delicate detail but maintain the feeling of light coming through the leaf. Making the leaf one stop lighter than middle gray has achieved this result.

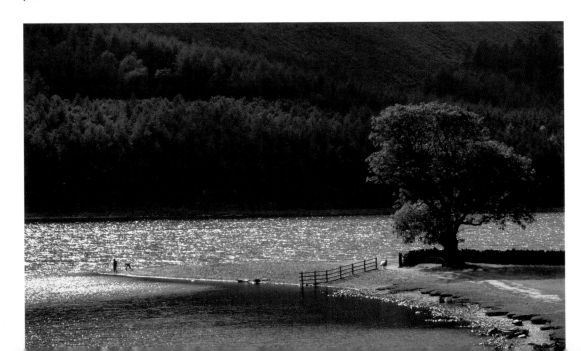

▲ Metering the sky

Clear blue sky is often considered to be a substitute for middle gray. In this scene, I metered the sky for an exposure to retain the rich color. Since a calibrated meter was used, a reading from the white building confirmed it would be exposed correctly.

PRACTICAL TASK

To calibrate your meter with transparency film, use the following visual method. The speed test for monochrome film is detailed on pages 122–123. To conduct this task, you need a textured, matte, white subject. A piece of textured, white decorating wallpaper is ideal.

1 Place your target in flat light, either overcast daylight or with the sun behind you.

2 Position the camera with normal lens at its minimum focusing distance from the subject. This should show a good area of subject.

3 Set the ISO for the film on the meter and take a reading from the white subject and set this on the camera. Now increase this exposure by two stops (that is, open the f/stop and make the first exposure.

4 Increase the exposure by a further half stop and make a second exposure.

5 Repeat step 4 a further three times. You will have made a total of five exposures, each progressively lighter in half-stop increments.

6 Finish the film and have it processed. Place the five pictures of the subject in sequence from darkest at the left to lightest at the right. Each image represents a different film speed.

7 Choose the image that you feel is the best exposure. It should look white but show the texture of the subject easily. If in doubt, ask other people for their opinion.

8 From the left, if the first image looks correct, your calibrated film speed is twice the manufacturer's ISO. If the third image is correct, use the normal ISO. If the fifth image is correct, your calibrated speed is one half the normal speed. The second and fourth images represent ISO values between the others, so choose the nearest value if one of these images looks best.

Whenever you use this film and processing combination in future, use this tested speed. You now know your light meter will give accurate results. To check the test, find some white subjects, such as buildings or flowers, and meter a white, textured area. Increase the indicated exposure by three stops, and the result should be perfect every time.

Meter linearity and color response

There are two aspects of light meter behavior that have a significant impact on the accuracy of the information they present to the photographer when assessing the SBR. The first I refer to as the linearity of the meter, and the second is the color response (spectral sensitivity) of the meter.

A light meter is designed to measure a specific range of brightness values. However, in most cases if the meter is used to measure brightness values near its limits of sensitivity, the readings shown by the meter may not be accurate. Ideally, a graph of the brightness response of a meter should be a straight line; in reality, it is more often a curve. In general, many light meters will overexpose a very dark area and underexpose a very light area.

General-purpose films have a panchromatic color response but light meters do not! Therefore, light meters and film respond to colors differently. In practice, if you meter a brightly colored object and expose according to the meter, the result may not be what you expected.

These problems have been significantly reduced by Zone VI Studios in Vermont, USA, who modify Pentax spot meters to make them more accurate. Only the meters bought from Zone VI Studios are modified, other meters must be corrected manually (see below).

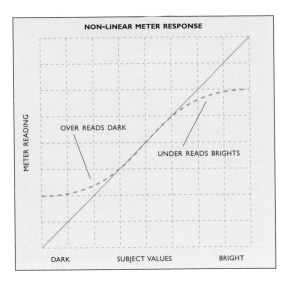

NON-LINEAR METER RESPONSE

METER READING

OVER READS DARK

UNDER READS BRIGHTS

DARK SUBJECT VALUES BRIGHT

Testing color response

When metering through monochrome contrast filters, you should first have tested your light meter's color response to establish a correction for each colored filter (this is not the same as the manufacturers' filter factor). The sequence shown here shows a strip of negatives that have been exposed through each of yellow, orange, green, and red contrast filters. The first frame is unfiltered and is the reference tone. To work out what correction you need to make, make several exposures through each filter, increasing the exposure by one half stop each time. The filtered

exposure that matches the unfiltered reference tone provides the correction for that filter. The respective correction is applied after assessing a subject through the chosen filter.

▼ Meter vs film

This sequence shows that the color response of the meter differs from that of the film. Each patch received the same relative exposure. If the color response of the meter matched that of the film each patch would be the same tone of gray. The difference would need to be compensated for after metering through the filter.

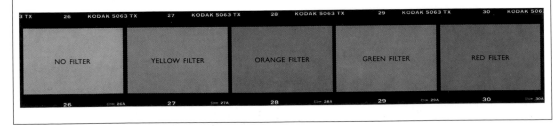

| 3 TX | 26 | KODAK 5063 TX | 27 | KODAK 5063 TX | 28 | KODAK 5063 TX | 29 | KODAK 5063 TX | 30 | KODAK 506 |

NO FILTER YELLOW FILTER ORANGE FILTER GREEN FILTER RED FILTER

| 26 | 26A | 27 | 27A | 28 | 28A | 29 | 29A | 30 | 30A |

PRACTICAL TASK

To test your meter's accuracy with light and dark brightness values, try the following experiment.

1 Place a piece of white card in a spot that gives a meter reading of around ⅟₆₀th @ f/4 using ISO 100 film. (If using a hand-held meter aim for an Exposure Value of 10). Expose one frame at the reading indicated.

2 Now place the card in bright sunshine to obtain a reading of around ⅟₁₂₅th @ f/16 (EV 15 on a separate meter) and expose a second frame.

3 Lastly, place the card in a dark location for a reading of around ½ second @ f/4 (EV5) and expose the third frame.

4 Process the film and examine each frame. If your meter is totally linear each frame should be the same tone (zone V).

If the second and third frames do not match the first frame determine whether they are under or over exposed and judge by how much. If necessary test your findings by re-testing and correcting the exposure for the second and third frames.

◀ **Metering strong colors**

When metering subjects with strong dominant color, it is important to understand how your light meter responds to color. The strong orange of this door would produce almost a one-stop underexposure with my Canon A1 TTL meter. However, my Zone VI Studios-modified Pentax meter produces accurate results.

Incident meters

Light falling on a subject is known as incident light or illumination, and incident light meters are designed to measure this. Incident meters are characterized by a white plastic dome that is usually the shape of a half sphere.

The white dome "averages" the total amount of light falling on it. The light is diffused by the dome and then measured by the light-sensitive cell of the meter. As with all light meters, incident meters should be calibrated to indicate exposure settings that will correctly reproduce a middle gray tone irrespective of the subject conditions.

The main advantage of the incident meter is that for average subjects under average lighting, the meter will indicate an average exposure that will produce a "straight" image of the subject. This image may or may not be what you want from the subject.

The greatest limitation of an incident meter is that it tells you nothing useful about the subject being photographed. In order to obtain the desired exposure under all circumstances, a photographer needs to know the subject brightness range of a scene and not simply measure the total amount of light that is falling on it.

▶ **Incident meter**
This typical meter can read both constant and flash light, or a mixture of both. It can also read multiple flashes.

▼ **Pointing directly at the camera**
These ferns were photographed in very soft, even light, ideal for accurate incident metering. In this case, pointing the dome of the meter directly at the camera would provide accurate exposure for a natural rendition. However, because this was photographed late in the day, I decided to retain the feeling of approaching night by slightly reducing the exposure to darken the result.

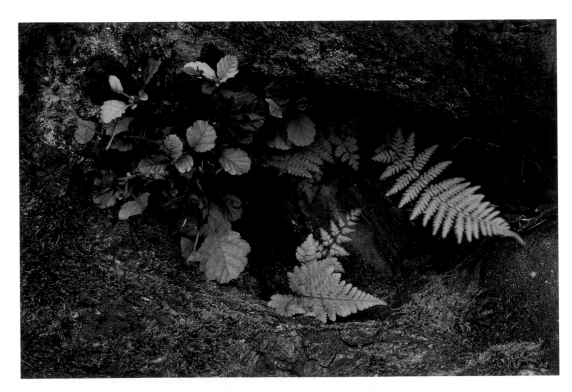

PRACTICAL TASK

Using a person as a subject, try the following exercise. To see the different exposures clearly, use transparency film – with print film, compensation may be made for the exposures when the negatives are printed. Make sure you make a note of the meter readings each time, so that you can compare the results. You will probably find that the readings taken midway between the camera and the light source give the most acceptable results.

1 With the sun behind the camera, take an incident reading pointing the meter at the camera, and expose.

2 Move the camera until the sun is at 45 degrees. (To do this, ask your subject to raise one arm in front and one arm to the side. Position the camera halfway between the subject's arms.) Now measure the light by pointing the incident meter at the camera, and expose.

3 Now point the meter between the light source and the camera, and measure the light again. Use this reading to make a second exposure.

4 Now move the camera so that the sun is directly to one side of it. Point the meter at the camera, and expose. Then point the meter midway between the light source and the camera, and make a second exposure using this reading. Finally, point the meter directly at the light source, and make a third exposure using this reading.

5 When the film is processed, examine each shot and note how the lightness and darkness of the subject changes.

▶ **Pointing halfway between camera and light source**

This subject is lit with side lighting, which tends to produce strong lighting. To avoid over-exposing the sunlit areas of the subject, an incident meter needs to be pointed midway between the light source and the camera. The result can be modified by pointing the meter farther towards the camera, which will increase the exposure and lighten the image, or by pointing it more towards the light, which will reduce the exposure and darken the image.

Reflected light meters

The light that bounces off an object is called reflected light. This light is measured with a luminance or reflected light meter. The amount of light reflected from a subject produces the visual brightness our eyes perceive. When discussing subject luminance in practical work, it is easier to visualize how light or dark a subject looks in terms of visual brightness.

▼ **Backlit image**

This type of backlit image requires the use of a reflected light meter to obtain accurate information. Readings were taken from the upper surface of the front table and compared with readings from the shadows. By increasing the meter reading from the table by one stop, I knew it would produce a bright surface but retain good color.

A reflected light meter translates the brightness of a subject into numeric values usable by the photographer. Some meters provide a display that shows an exposure value (EV); this can then be transferred to a dial showing the aperture and shutter speed combinations that will provide the required exposure. Others directly display the recommended aperture and shutter speed combination.

Modern light meters may also have other functions such as multiple readings, averaging two or more values, and storing values. Some also have zone system scales built in.

If used correctly, a reflected light meter can provide the information needed to determine the SBR of any subject in any conditions. This is

Learning to use meters

You must become completely proficient with whatever equipment you use. This applies particularly to light meters.

• Read and reread the instruction booklet for the light meter you own.

• Become familiar with every function the meter provides.

• Experiment by "playing" with the meter at home or around the garden.

• Make sure you understand exactly what the information on the meter display means for each mode of operation.

This may sound like common sense, but I meet many photographers who struggle simply because they don't know how to operate the controls on their camera or light meter.

crucial for complete creative control of exposure. However, reflected light meters with a wide measuring angle average all the brightness values in the area being read to produce the recommended exposure. Since the meter cannot know what is being measured, the meter will be misled if taking readings from predominantly light or dark areas. It is for this reason that many photographers prefer spot metering.

▼ Light from outside

Again, only a reflected light meter could be used in this situation. An incident meter would simply have metered the light inside the airplane, which had nothing to do with the subject outside! By metering the sky (not the sun) and the airplane wing separately, a suitable exposure that would hold detail in both was determined.

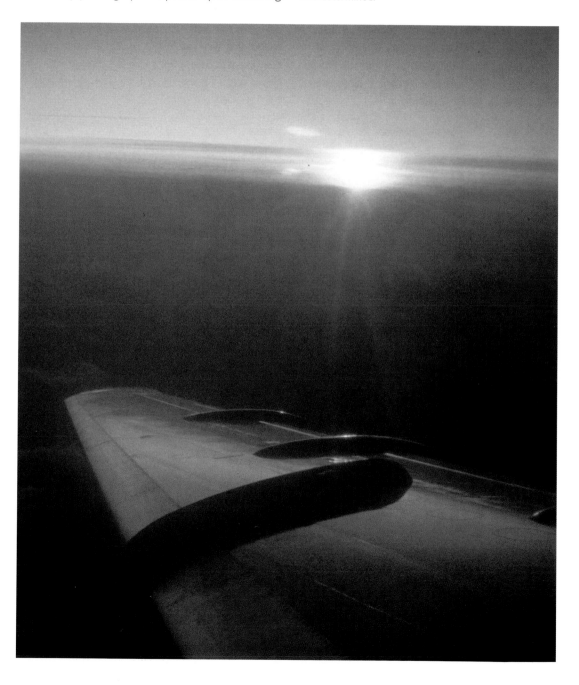

TTL meters

Most SLR cameras have a built-in light meter that reads the light actually passing through the lens of the camera. These light meters are known as TTL (through-the-lens) meters. All TTL meters measure reflected light.

There are often several options available with TTL meters. These options may include averaging, center-weighted, multiple-segment, or spot metering on either manual or automatic control. The mode you select will usually depend on the type of subject you are photographing. The camera may also have other functions that can be used in conjunction with the meter, such as memory for holding several light readings when assessing SBR.

The main problem with any averaging system, such as multi-segment mode, is that subjects with predominantly light or dark tones will usually result in inaccurate information. This problem applies also to non-TTL meters. Remember, all meters assume the subject is "average."

For creative work, by far the most useful method of using a TTL meter is in manual spot mode. This gives you the facility to take individual readings from small areas of your subject, something that makes accurate SBR determination easier. See pages 52–53 for advice on improving TTL metering for cameras without a spot mode.

◀ **Metering pattern**
The TTL metering pattern of a Canon EOS 3 superimposed on the viewfinder display. The yellow and pink areas show the bias for spot-metering mode.

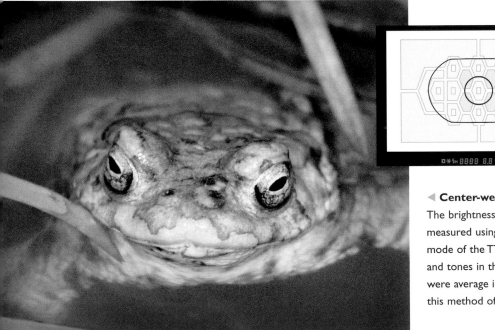

◀ **Center-weighted mode**
The brightness of this frog was measured using the center-weighted mode of the TTL meter. The colors and tones in the lower center area were average in brightness, ideal for this method of metering.

▶ Spot mode

This subject would have fooled center-weighted metering by being brighter at the bottom than the top. Spot mode was used to take readings from the wall.

◀ Multi-segment metering

Multi-segment metering takes several readings from different areas of the subject. In this case, the tree bark provided an accurate measurement due to the distribution of tones.

Hand-held meters

The most versatile light meters are those known as hand-held meters. These meters are available as incident or reflected light types, with many offering both methods of measurement. A dedicated light meter is essential for most medium- and large-format users, and I would also recommend them in place of the TTL meter of an SLR camera.

▼ Unusual lighting

Hand-held meters are ideal for unusual lighting situations. In this woodland scene, I had to work quickly because the light was changing rapidly. Using the TTL meter would have been too slow because the camera was on a tripod, so I used a separate spot meter to quickly measure the bright grass and increase this reading by one and a half stops.

The various models available offer different facilities and modes of operation. The simplest may provide only incident and reflected ambient metering, with a fairly wide measuring angle. More sophisticated models will have features such as electronic flash measurement, spot metering, and multiple readings. They may also have memory to hold different readings, and even zone system scales for assisting with SBR determination.

When used correctly, the most accurate and flexible meters are the one-degree, spot-reflectance type (some of which have both flash and ambient modes). Only a spot meter will permit you to accurately assess the subject brightness values and determine the SBR of any subject under any conditions.

Many separate meters have complex displays showing various symbols and figures. It is important that you fully understand what all the symbols mean so you can use the meter quickly and confidently.

▶ Hand-held types

Two examples of the type of sophisticated light meters currently available. On the left is the Minolta Spotmeter F, and on the right a Sekonic L508 Zoom Master.

▼ Sun and shade

When it is not possible to move close to the subject, spot metering is the best choice. The camera was tripod-mounted, so it was more convenient to use a separate spot meter. Exposure was based on readings from the grass in sunlight and the dark background.

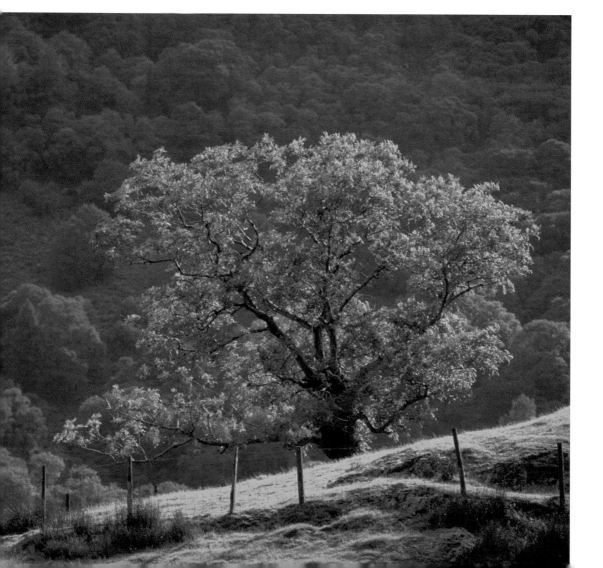

How surface angle affects readings

All surfaces reflect light to some degree, which allows us to see them. The brightness produced depends on the surface characteristics. A light-colored, glossy surface reflects more than a dark, non-glossy surface.

However, the brightness of a surface is also affected by the direction you view the surface from in relation to the light source. This is related to physics and the principle that angle of light incidence equals angle of reflection. This can cause problems if a reflected light meter is used incorrectly.

This principle can also be a problem when using incident light meters. Incident meters use a dome-shaped diffuser to average the light falling on the meter. Just as the surface angle of a subject is important, if the meter's dome is pointing in the wrong direction the angle of the dome to the light will be incorrect and the reading so obtained will be inaccurate.

Once the camera position is finalized, the lens "sees" each subject surface at a certain angle relative to the light source. It is this line of sight that determines the brightness of each surface and from where it should be metered. Remember that outdoors the sun moves constantly, so brightness values in the subject change over time.

▼ **Multiple angles**

This large rock demonstrates the importance of surface angle and metering because it has fairly flat sides at various angles. To determine exposure, the left side of the rock was placed on zone VI. The large shadowed side fell on zone IV, and the white clouds on zone VIII. A polarizing filter accentuated the blue sky.

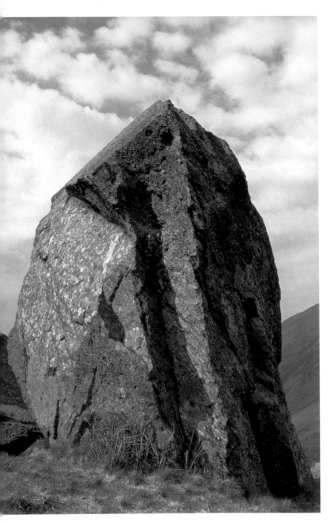

PRACTICAL TASK

To understand this principle better, experiment with a piece of card.

1 Stand the card on a table with a window directly to one side. Sit on a chair to fix your position (this is the camera position).

2 Now slowly rotate the card first towards the window and then away, and notice how the brightness of the card changes.

3 Use your meter to check the brightness of the card at different positions.

4 Stand the card in one fixed position, and move yourself from side to side and meter the card from different angles.

Note the variation in the readings. Note also that even a small change in angle can result in a large difference in the reading.

Changing values

This close-up sequence demonstrates how the brightness of a surface is influenced by its angle to the light source and camera. The exposure for each image was constant, but the value of the Kodak gray card varies from dark (zone IV) to light (zone VI). The actual exposure was determined by metering the light side of the rock and increasing this by one stop (placed on zone VI). The shadows were two to three stops darker (they fell on zones III and IV).

▲ Card in shade

In this first image, the card is facing away from the light and is effectively in shade. The tone of the card is darker than normal.

▲ Card towards camera

This image shows the card facing the camera. A meter reading from the card, zone V, corresponded with the exposure being used.

▲ Card towards light

In this image, the card is facing towards the light. Note how the tone of the card has become lighter (zone VI).

Changing exposures

This sequence simulates what happens when you meter from a position away from the line of sight of the camera. This also shows what will happen if an incident meter is incorrectly used by pointing the white dome in the wrong direction. As before, the angle of the Kodak gray card has been changed in each case. The card was metered to determine the exposure for each image.

▲ Card facing camera

This image shows one position for the card. The exposure was based on the reading obtained from the card. This has resulted in slight underexposure. No other readings were taken.

▲ Card facing light

As the card is turned towards the light, it becomes brighter. Taking a new reading from the card and using this reading results in the card being the same tone as before, but the rocks have darkened (the exposure was less than the first image).

▲ Card in shade

By turning the card slightly away from the light towards the camera, it becomes darker. A meter reading from the card now requires more exposure to obtain the same tone for the card. This has lightened everything in the scene.

How to take a meter reading

We know that the brightness of a subject is affected by the angle at which the light strikes the subject and the camera's line of sight. To measure this brightness accurately, a reflected light meter reading should be taken as close as possible along the camera's line of sight to the subject. The further away from this line of sight you measure from, the more inaccurate the reading is likely to be.

With a spot meter you should meter from slightly in front of (or adjacent to) and as close as possible to the lens. With a wider-angle meter, which necessitates moving closer to the subject, try to meter along a line of sight from the camera to the subject being read. Remember that your light meter thinks everything is middle gray and so will indicate a reading that will produce a zone V tone in the image (see pages 54–55). You can choose on which zone you finally place the area by increasing or reducing the exposure indicated by the meter. The other areas of the subject will then fall somewhere on the zone scale relative to this first placement (see page 55).

With incident meters, the reading will be affected by the direction in which the white dome is facing. The usual advice that you should always point the dome at the camera does not work for all situations. In fact, this will only be accurate when the lighting is overcast or the sun is within approximately a 45-degree angle from the camera. My experience suggests that the white dome should point mid-way between the camera and the light source if the best balance between light and dark areas is to be obtained. Unfortunately, an incident meter will not permit assessment of the SBR, so proper visualization is not feasible.

◄ **Incident readings**
This subject was metered using an incident meter. Since the scene was lit by side lighting, the dome of the meter was pointed mid-way between the camera and the sun to prevent over-exposure on transparency film. This also ensured the very light rock in the foreground would not "burn-out." To create a gentle mood and add a slight glow to the light values a mild soft focus filter was used on the lens.

Meter technique

A simple subject, such as the one shown here, is ideal for practicing metering technique. The meter reading from the dark side of the black pot was 12 on my spot meter, which indicated an exposure with ISO 100 film of ⅟₆₀th second at f/8. Reducing this exposure to ⅟₆₀th second at f/22 "places" that area on zone II. Checking other areas, the barn door and sunlit side of the black pot both gave a reading of 14, while the neck of the white pot gave readings of 17 and 18. Comparing these readings with the first (12)

we can determine which zone each area will "fall" on, e.g. 14 is two stops lighter than 12, so the barn door must fall on zone IV, two zones lighter on the zone scale. The brightest white (18) is 6 stops lighter than 12, so must fall on zone VIII.

The brightness range is normal and uses the full texture range, from zone II in the shadows of the dark pot to zone VIII on the sunlit area of the neck of the white pot. For a "natural" rendition, normal (N) development would be required.

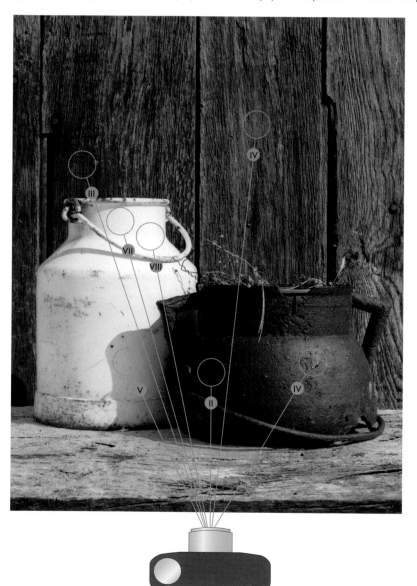

Camera

Reducing the measuring angle

The measuring angle of a light meter determines how much of the subject will be measured from any given distance. As stated earlier, the most accurate metering is with a separate, one-degree spot meter. However, if you have a wide-angle meter or your camera uses any form of averaging TTL metering, it will often include light from around the main area you want to measure. It is a good idea to be able to reduce the measuring angle to provide increased accuracy.

The easiest way to narrow a TTL meter's angle of measurement is to meter through a long focal length lens. Changing from a 50mm to a 100mm lens will reduce the meter's angle by one half, allowing a smaller area of the subject to be measured. Once the exposure has been determined, you can change to the lens you want to use. If you use a zoom lens to do this, be aware that some zooms reduce the light a little as the focal length increases. Therefore it may be necessary to increase the exposure reading when zooming out for the picture or changing lenses.

With separate meters, the measuring angle can be reduced by placing a tube in front of the measuring cell. The tube reduces what the meter "sees," hence effectively narrowing down the measuring angle. There will be some loss of light due to the tube, which requires compensation. I refer to this as the exposure factor of the tube.

▲ **Moving closer**
When using a wide-angle meter—this has a 40-degree measuring angle—it helps to move close to the subject, but this is not always accurate enough. At around 1 foot (30 cm) away from the tree, an area of approximately 8 inches (20 cm) is being measured, as shown by the red circle. The background is affecting the reading.

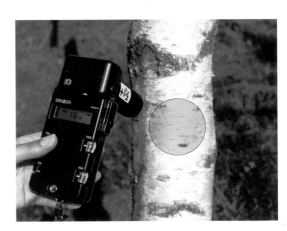

▲ **Using a tube**
Adding a tube to reduce the angle permits smaller areas to be measured. Here, the length of the tube has been calculated to halve the measuring angle from 40 degrees to 20 degrees. This required a 90mm tube. The area being measured, as shown by the red circle, is now only 4 inches (10 cm) and includes just the tree bark. Note the exposure factor of +1.5 shown on the tube. The meter reading is increased by 1.5 stops to compensate for the tube.

Tube exposure factor

It is a simple matter to determine the exposure factor for the tube as follows:

1 Without the tube on the meter, meter a large smooth evenly lit wall. Note the reading obtained.

2 With the tube in place, again meter the wall. Make sure the meter is pointing in the same direction as before.

3 The difference in stops is the factor for the tube. Write this on the tube!

When you use the tube on the meter, increase the indicated exposure by the tube factor.

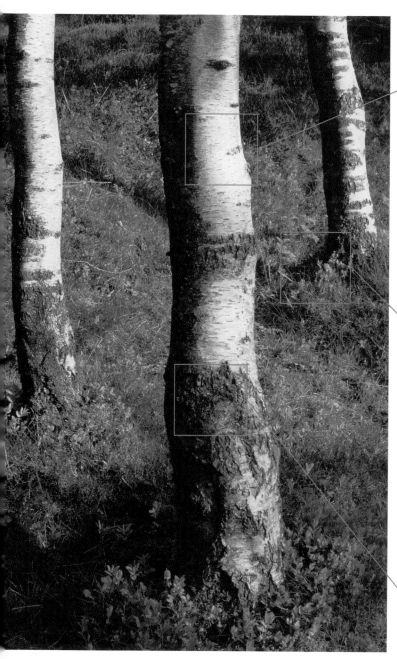

Light tones

A meter reading of the lightest area of the tree bark indicated $1/125$th second at f/22. This was increased by $2\frac{1}{2}$ stops to lighten the bark but retain good detail (zone VII$\frac{1}{2}$).

Medium tones

A third reading from the sunlit grass at the base of one of the trees indicated $1/125$th second at f/11. This is only two stops darker than the light bark, and so would produce the desired result (zone V$\frac{1}{2}$).

▲ Too much background

When a subject has narrow areas of important detail, such as these tree trunks, wide-angle meters tend to be influenced too much by the background. These three examples show zoomed-in views of the main subject from the camera position, using a 210mm focal length.

Dark tones

A second reading of the darker bark indicated $1/125$th second at f/5.6, four stops darker than the lightest bark. This reading indicates the dark bark will be within the detail range of the film (zone III$\frac{1}{2}$).

Exposure control method

In the 1940s Ansel Adams and Fred Archer devised a practical method of obtaining the desired exposure for any scene based on your personal creative vision. This method is still the best way of determining exposure for both color and monochrome films, and will be discussed in the following pages. Before exploring this exposure method, it is necessary to understand some basic concepts.

Although the visual world is made up of an enormous variety of color, for exposure assessment it is useful to think initially in tones of gray. Tone values can range from black to white, with unlimited shades of gray between these extremes. The full continuous tone range is represented visually with a gray scale. A gray scale is a graphic representation of how the real world appears in gray tones.

To relate the continuous tone scale to exposure control, Adams and Archer decided to divide the continuous scale into 11 discrete equal divisions. Each division contains a section

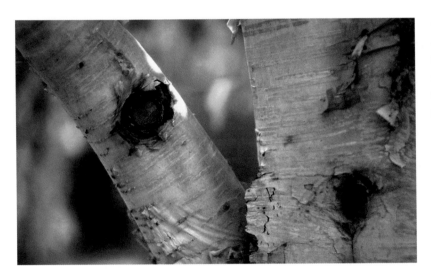

◀ **The gray scale**
Although most scenes contain color, for exposure assessment it is useful to imagine the subject in tones of gray.

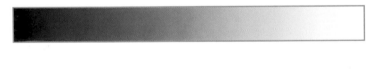

◀ **Continuous scale**
The tones of the subject are continuous, and can be shown as a gray scale from black to white.

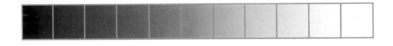

◀ **Segmented scale**
The gray scale is divided into eleven steps called zones. Each zone contains a small section of the continuous scale.

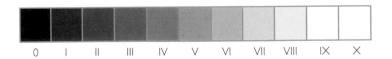

◀ **Zone scale**
For convenience, each zone is made into one tone and numbered as shown, with zone V being the same tone as 18 percent middle gray.

of the continuous gray scale but represented by one tone. To identify each segment, it is given a unique number, starting with 0 for black up to 10 for white. Starting with black, the center of each division or zone is twice as bright as the previous division through to white. Each full step on the scale is the same as a one-stop change in exposure. We call this segmented gray scale a zone scale.

The center zone of the stepped scale is zone V. Zone V has a gray tone that matches the middle gray of the Kodak gray card. As we know, this is the tone that a light meter produces. The beauty and simplicity of this method is that if you want to make something lighter or darker than middle gray, you simply increase or reduce the exposure accordingly. By using the zone scale as a visual aid, it is easy to see how light or dark something will be in the image, and by how much the exposure needs to be changed to achieve what you want. This is the essence of visualization.

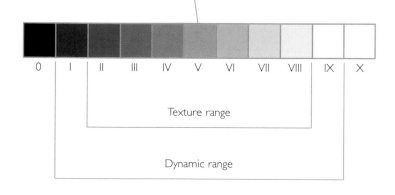

◀ **Meter one area**
Any single subject tone can be metered and placed on any zone of the scale. The meter places it on zone V – to move it to the required zone, increase or reduce the meter reading by one stop for each zone.

◀ **Place reading on the scale**
In this example, I wanted the bark to be light in tone so the meter reading needed adjusting. By increasing the indicated exposure by 2 stops, the bark is placed on zone VII, a lighter tone.

Increase the exposure by two stops

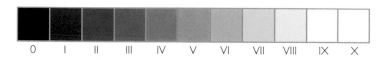

Defining normal SBR

When considering a new scene or subject, it is worthwhile comparing it to what we can define to be a normal subject – that is, one in which the areas that require texture or detail in the print range from zone II to zone VIII. This is known as the texture range. Other areas in the image may be zones O, I, IX, and X values. These will have no detail in them, but complete the full zone scale and add quality to a print or transparency.

The range of zones from I to IX is known as the dynamic range. If a subject contains a normal range of zones, giving the film optimum exposure and development will produce an excellent-quality transparency or print without any problem.

A normal subject has a useful brightness ratio of 128:1 or 7 zones (II to VIII inclusive). This corresponds to the texture range defined above. In most cases there will be areas of the subject that fall on the lower and higher zones, but these areas would normally be relatively small.

To recap: any subject with a brightness range from zone II to VIII is a normal range subject and would be exposed and developed normally for a naturalistic result.

It is important to realize that although the texture range starts at zone II, this represents a very dark tone. The detail in a zone II area is virtually imperceptible. The first zone that produces a fully detailed dark tone is zone III. Therefore, if you have a dark area of the subject that you want to retain discernible detail in do not place it lower than zone III (that is, do not reduce the meter reading from that area by more than two stops). Because a zone II has minimal detail some photographers prefer to think of the texture range as being zone III to VIII rather than zone II to VIII.

▼ **Exposure**

Another normal scene in color. The important areas were metered and positioned on the zone scale by use of exposure. Adjusting the amount of exposure allows you to lighten or darken the tones of a scene.

▶ **Light meter**

I assessed this scene with the light meter and decided that detail would be well recorded by treating it as a normal subject, so it was sufficient to expose accurately and develop normally to obtain a good negative.

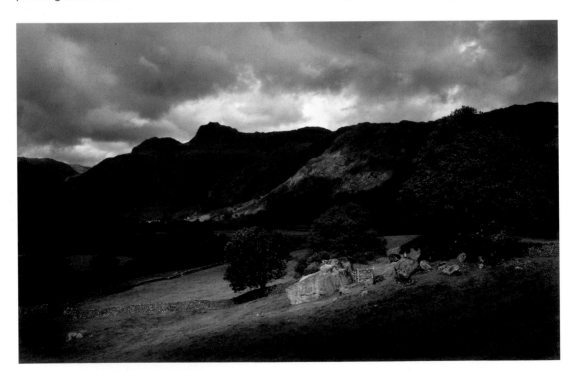

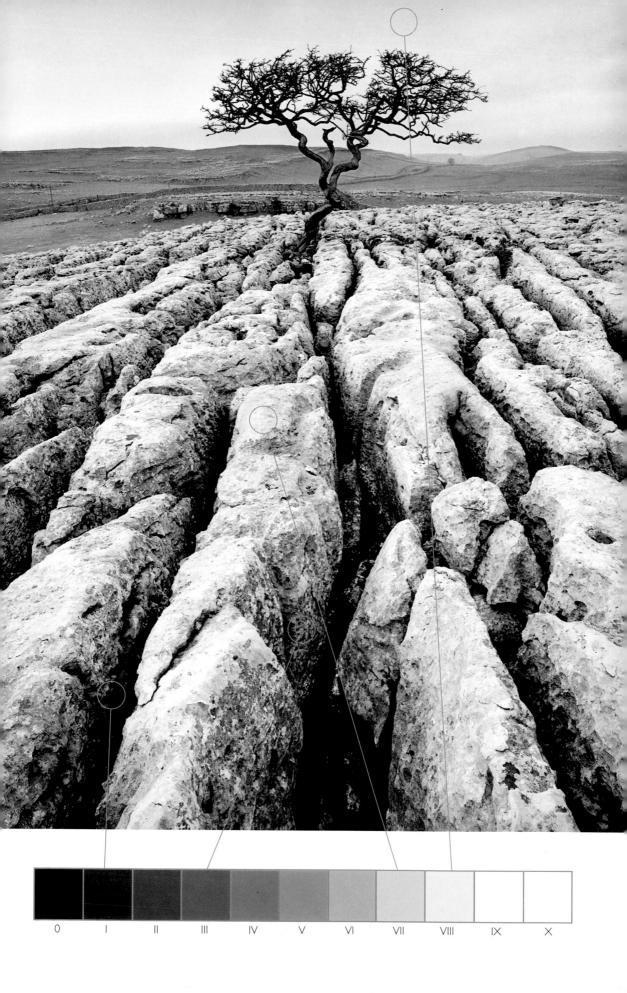

0 I II III IV V VI VII VIII IX X

Defining other SBRs

Short-range subjects

Since the normal subject brightness range for detail is defined as being zone III to zone VIII, any subject with a SBR where full detail is desired of less than six zones is considered to be a short-range subject. Short contrast-range subjects are often referred to as low-contrast because they usually (but not always) occur in overcast or dull conditions for out-door subjects.

A short-range subject uses fewer zones than normal, so the result can look dull and flat. Short-SBR subjects can be made lighter or darker overall, without losing detail, simply by increasing or reducing the exposure.

Long-range subjects

If the full detailed SBR is more than six zones, it is considered to be a long-range subject. More commonly, we would say the subject has high contrast. A long SBR means the darkest and

▼ **Short-range subject**

This simple landscape has a short contrast range. The mood of the scene could be adjusted by increasing or reducing the exposure without losing detail anywhere.

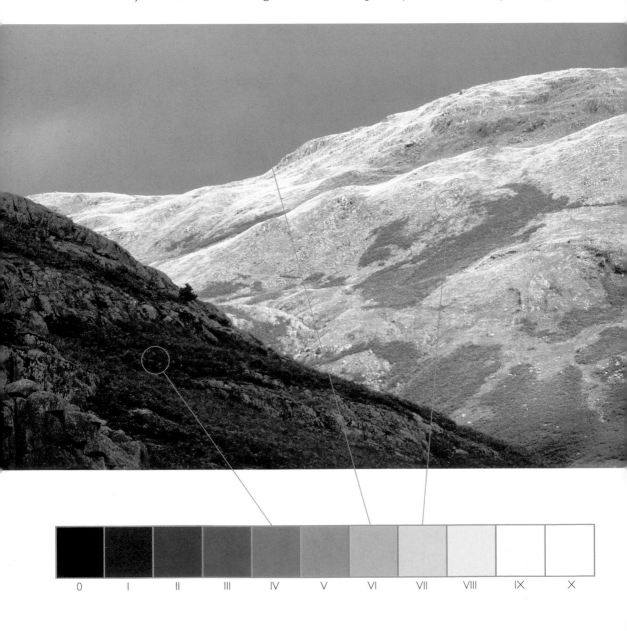

0	I	II	III	IV	V	VI	VII	VIII	IX	X

lightest areas that require full detail fall outside the texture range of the film. For example, if the required detailed areas of the subject range from zone I to zone IX, you would lose detail, because the actual texture range is only zone II to VIII. In this case, you must either visualize the image differently by accepting a loss of detail in selected areas, or compromise by using contrast-reduction techniques to reduce the SBR to retain the detail.

Remember, for practical use, SBR refers only to the areas of the subject in which detail is required.

SBR summary

Short range SBR is less than 6 zones.
Normal range . . . SBR is 6 zones.
Long range SBR is more than 6 zones.

▼ **Long-range subject**
When the SBR is greater than normal, compromises on detail must be made. In this case, the exposure was assessed to retain the dramatic sky and silhouette the stone circle for a deep, moody rendition.

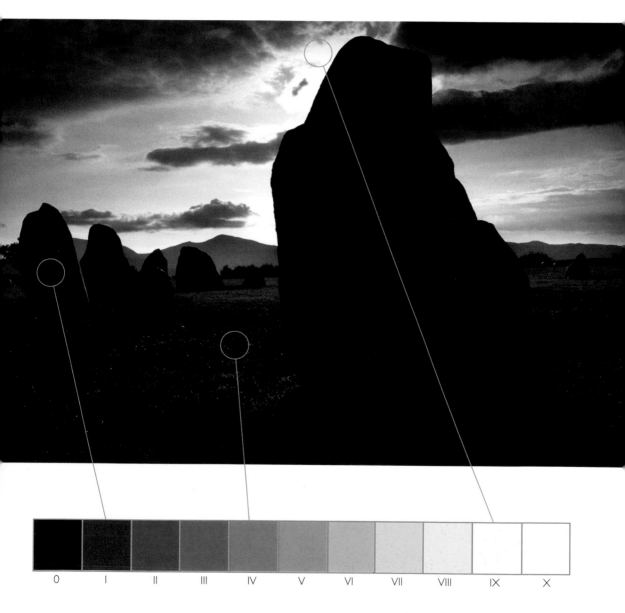

| | 0 | | I | | II | | III | | IV | | V | | VI | | VII | | VIII | | IX | | X |

Advanced exposure system

One of the main strengths of the zone system is that it allows visualization of an image prior to exposure. This benefits all photographers with all film formats. However, the visualization aspect of the system permits even greater control when you use it at the camera stage to assess how you can change an image by post-exposure manipulation. The main forms of image manipulation after exposure are development of the film, for both color and monochrome, and paper contrast control in monochrome printing.

Development changes can be used with color and monochrome film to control difficult SBR subjects or to realize a personal interpretation.

For color transparency film, most professional processing labs will "push" (increase) and "pull" (decrease) color development. A low-SBR scene can be improved by increasing film development to expand the image contrast on the film. Conversely, higher than normal SBR scenes can be compressed by decreasing film development. This is also a very powerful method to use when creating departures from reality.

If individual film development is not practical – for example, for small-format users who use only one camera – similar control is available in the darkroom using printing paper contrast manipulation.

Adjusting contrast in printing

Low SBR scenes allow greater control during monochrome printing because a correctly exposed and normally developed negative will contain plenty of detail throughout the scene. However, high SBR subjects do not allow this flexibility.

Grade 2

This scene, photographed on 35mm film, was softly lit and hence low in contrast. The negative was exposed and developed to place the lighter areas correctly. This meant that the shadows were full of light and detail. With low-SBR subjects, this permits different visualizations when printing.

Grade 3

Increasing the paper contrast to grade 3 allowed the darker tones to be lowered in value to create a print with a fuller tone range. However, the image is beginning to lose the gentle quality of the original lighting.

Grade 5

Increasing the paper contrast even more allows more graphic interpretation of the scene. In this case, using approximately grade 5 some of the darker tones are merging into black. Each of these interpretations could have been anticipated at the time of exposure in the camera.

▲ **Increasing contrast**

Using lower than normal exposure and a film development increase of one half-stop, I was able to increase the color saturation of the sky and green leaves and improve the image contrast. These changes were fully visualized at the time of exposure, so the final image is as expected.

Exposure system for color and monochrome

The exposure system described on the previous pages is equally applicable to color and monochrome photography. The behavior of all photographic emulsions is based on known physical and chemical reactions, and is known as photographic sensitometry.

On a practical level, all normal films need to be exposed to light to start the image-making process. Because the exposure methods of the Ansel Adams system are about exposure technique, it doesn't make any difference which panchromatic film is in your camera.

What will affect your final image is the individual characteristics of a particular film. The way a film handles different colors, the rendition of detail, the tonal separation possible, all go towards giving an image its unique appearance. These film characteristics can only be learned by testing and using a particular film.

However, none of these things affect the actual method of determining exposure for a particular subject. The exposure method, once mastered, is applicable to every photograph you ever make. It is worth devoting the necessary time to learning the method since it will save you much time, money, and heartache in the future. It will also increase your success in image creation and boost your confidence.

▼ **Monochrome image**

When assessing the exposure for this monochrome image, I again used spot metering but based the exposure on the lower zones. An orange filter was used to increase the contrast by removing the haze. The shadows were metered through the filter and placed on zone II½. Development was normal, because the clouds fell on zone VIII.

▶ **Color image**

This image was taken during the same session as the monochrome image, but made with transparency film. It was vital to retain the cloud detail, but my spot meter indicated that the contrast was low, due to the presence of haze. To improve the image, I exposed the white clouds on zone VI½ and instructed the lab to process the film N+1½.

Assessing normal subjects

Let's examine how to use the exposure method in practical work. The first step is to decide what appeals to you about the subject, and how best to capture that response in the final image. This is your visualization. At this stage you will also make the compositional decisions that will determine the camera viewpoint, choice of lens focal length, and depth of field.

Once the camera is in place, it is time to assess the subject brightness range. To do this decide which areas of the subject you want to retain detail in. Take care – it is a common mistake to select areas for detail that in fact don't need it. Concentrate on important parts of the subject.

Use your light meter to measure the brightness values. The meter will tell you which is the lightest and which is the darkest. In the image shown opposite, the leaves in shadow at lower left were the darkest important area, while the sunlit, pale wall was the lightest. The light meter indicated that the difference between them was five stops, which is a normal SBR.

I decided to create a natural rendition of the scene to retain the feeling of good light and full shadows. Therefore, it was simply a matter of metering the shadowed leaves and reducing the exposure by two stops to place them on zone III of the zone scale. Since the light wall is five stops brighter, it automatically fell on zone VIII.

▲ **Windswept grass**
Bright cloudy weather often gives normal SBRs.

▶ **Normal subject**
A normal SBR subject that only requires careful exposure assessment and normal development to obtain a good negative.

PRACTICAL TASK

The best way to become proficient at assessing different subjects is simply to practice metering without actually taking pictures. Use the following procedure:

1 Choose a subject.

2 Select the darkest area in which you feel detail should be seen, and meter just this area. Do not choose very small areas because they are not important for this.

3 Note the reading.

4 Now select the lightest area in which you would like to see detail and meter that area.

5 Determine the difference in number of f/stops between the two readings.

6 Decide from this whether or not the subject has a normal SBR.

Now do the same thing on various other subjects until you are completely happy with the method.

0 I II III IV V VI VII VIII IX X

Assessing difficult subjects

Quite often, you will be faced with a subject that has a SBR of more than five stops. This means that the difference between the darkest and lightest areas in which you want detail is outside the texture range of the film.

The image shown below is just such a subject. The large rock is under the trees, while the distant hillside through the trees is in bright light. In this case, I wanted some detail in the tree trunks, but also wanted to retain some tone on the far hillside. The meter readings indicated that the difference between these two areas was seven stops, more than a normal texture range.

To deal with this, I placed the darkest tree trunk on zone II by reducing its exposure reading by three stops. This meant the hillside would fall on zone IX, one zone higher than the texture range. The solution in this case was to reduce the development of the film by one zone to lower the value of the hillside

to zone VIII, retaining detail. An alternative would have been to expose the tree trunk on zone II as required, develop the film normally, and then print on a lower-contrast paper or use split-grade printing on variable contrast (VC) paper in the darkroom.

For a similar subject in color, the same exposure and reduced development procedure would work well. However, it may be necessary to also use a slightly warming filter on the camera to counter the cooling effect of reduced development on color film.

▶ **Contre-jour**

Contre-jour subjects usually have a wide SBR and require careful metering. The brightest reflections on the water in this image were ignored in favor of the tree, which was placed on zone IV to retain some color. A subject like this will test your technique and materials to the full. Use of the zone system will allow accurate visualization and subsequent exposure.

▶ **High SBR**

For a higher than normal SBR, such as here, careful exposure combined with post-exposure techniques are required to control the contrast and obtain the desired image as detailed in the main text.

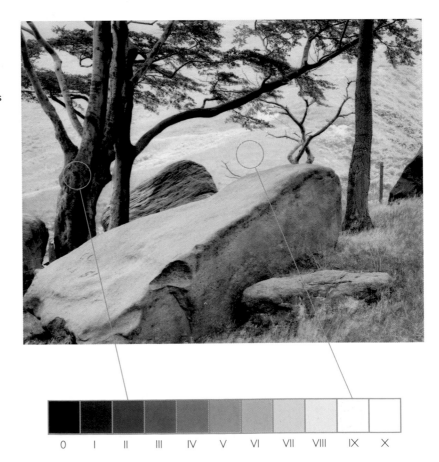

0	I	II	III	IV	V	VI	VII	VIII	IX	X

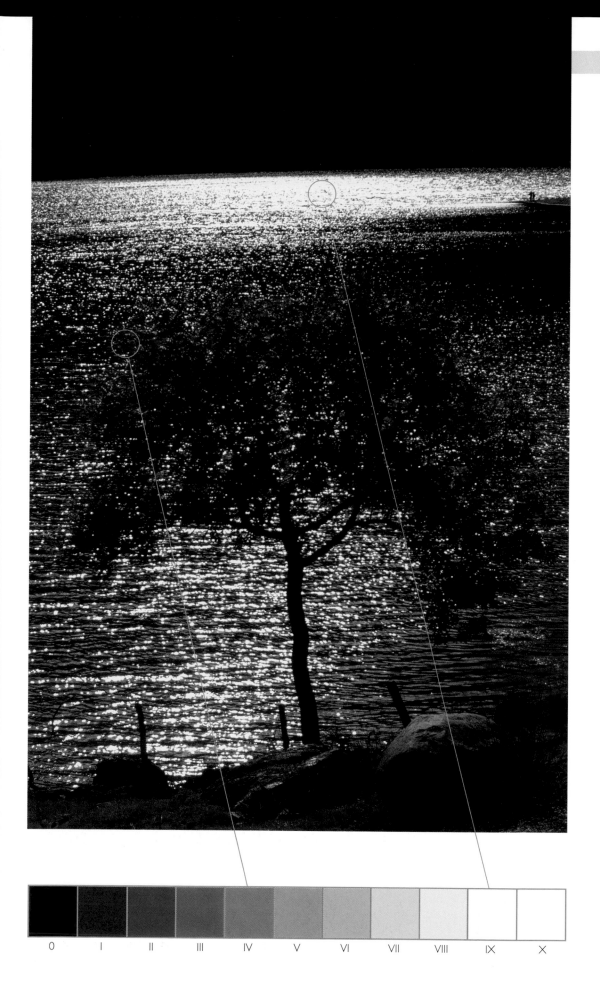

0 I II III IV V VI VII VIII IX X

Departures from reality

"Departure from reality" is the expression Ansel Adams used to describe an image that has been modified using whatever techniques the photographer desires, in order to realize a personal visualization of the subject. A departure from reality may be very subtle or quite extreme, depending on the desired image.

In actual fact, nearly all images are departures from reality, by virtue of the limitations of the photographic process and the basic controls used to achieve a "normal" rendition of the subject. However, the term is mostly used in the creative sense to imply that the photographer has consciously manipulated the creation of the image to make a personal statement, or achieve the best record of the scene.

The examples shown here have been manipulated to create the image seen, and look nothing like the original subject as seen in reality. The techniques used here were very simple and are easy to utilize.

▶ **Bright weather**

This scene looks dramatic, but was actually shot just after midday in bright weather. It was the choice of viewpoint and high contrast that allowed this brooding image. By basing the exposure on the sky and sunlit areas only, the shapes of the arches have been emphasized. In this example, the development of the film was normal, but some print manipulation was required.

▼ **Flat light**

This close-up of the plant ecosystem found on a rock was photographed in very flat, dull light. To try to create some modeling to enhance the textures, I held a black cloth close to the left of the subject. I also exposed the subject to allow a one-zone development increase to further improve the contrast. This technique also had the effect of improving the color saturation. This image was shot on Fuji Velvia film.

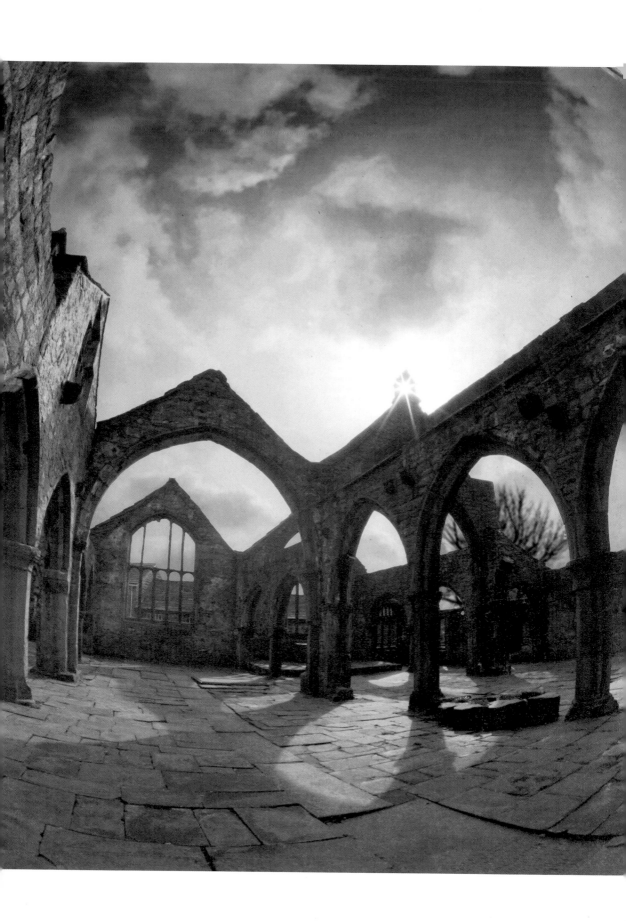

Film development

Development is responsible for the formation of the visible image on the negative or transparency. Light areas of a subject expose the film more than dark areas, and so affect more silver halides on which the developer can work.

Since development affects heavily exposed areas more than less exposed areas, increasing or reducing the development of an image has more visual effect on the lighter areas of the scene. This makes it possible to control different SBRs at the development stage. Low- or high-SBR subjects can have their tonal values expanded or compressed by increasing or reducing development.

With color film processing, the first stage of the process is similar to monochrome film development. The first developer creates a black silver image that is later converted into a dye image during the color development stage. It is useful to remember that all films, whether color or monochrome, respond to development changes in a similar way. The main difference with color materials is that a color cast can be introduced that needs to be filtered out.

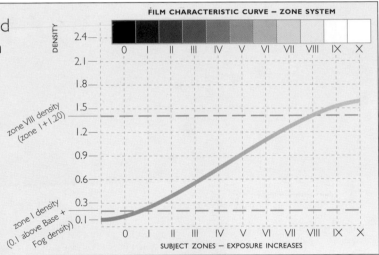

Normal exposure and development of film

Plotting exposure and development against the density produced on the film gives a typical characteristic curve. This chart shows the optimum density values for zone I and zone VIII to produce an excellent normal negative. Base + fog refers to the density of the unexposed film between the frames.

FILM CHARACTERISTIC CURVE – ZONE SYSTEM

DENSITY

2.4
2.1
1.8
1.5
1.2
0.9
0.6
0.3
0.1

zone VIII density (zone I + 1.20)

zone I density (0.1 above Base + Fog density)

SUBJECT ZONES – EXPOSURE INCREASES

◀ **Allowing darkness**
Normal development has been combined with correct exposure to retain the tonal values of the stone columns. The rest of the scene was allowed to go dark to accentuate the line of movement toward the solitary figure created by the building.

Testing film

The majority of people have their color film processed at a professional laboratory under strictly controlled conditions. For complete creative control, it is necessary to test the processing so that increased and reduced development can be utilized. (The procedure is similar to that on pages 104–105.) Most labs refer to increasing development as "pushing" the film, while reducing development is known as "pulling." Generally, pulling film causes a cool color cast to appear, while pushing film tends to produce a warm cast. Each film should be tested to determine the exact color cast. The color cast can be filtered out at the camera stage, with the appropriate CC filter, or when making prints.

▲ **Tonal values**

To achieve the desired tonal values in the image, it is important that the correct development is given for the brightness range of the subject. Although this subject was photographed in gentle light, the SBR was normal for my interpretation, so normal development was indicated.

Determining optimum development

Ideally, every subject should receive the optimum development to record the tonal values exactly as the photographer wants them. This is fine with sheet film, because each sheet can be developed singly. Roll-film users need to use separate camera bodies or film backs so each roll receives the necessary development. Monochrome users can also utilize paper contrast during printing as part of their control technique.

Accurate visualization of a subject as an image is only possible if the tonal values are controlled through appropriate exposure and development. If development is inaccurate, when you expose an area of a scene on a specific zone it will not actually be that zone in the film image. For 35mm users, a compromise can be made by combining reduced development of the film with paper contrast grades.

Before attempting to find the optimum development for a film, it is crucial that you first establish your personal film speed for that particular film.

PRACTICAL TASK

Follow this simple method to visually check your film development. Choose an overcast day so the light remains even.

1 Using a piece of rough-textured artists' paper (or similar) as your subject, fill the frame with the subject and take a reflected light meter reading. Expose one frame at this reading: this is a zone V exposure.

2 Now make a second exposure exactly three stops more than the first. This is a zone VIII exposure, used as the reference point for development calibration.

3 Develop the film for your normal time, fix, and wash as usual.

4 In the darkroom use the first negative, the zone V exposure, to make a print. This needn't be very big, about 5 × 4 inches. Make the print so that the tone of gray matches as closely as possible a Kodak gray card. Dry your test strips to allow for the dry-down effect. Don't be in a hurry over this.

5 Once you have the zone V print time from step 4, exchange the negative for the zone VIII exposure and make a second print for the same printing time.

6 Process and dry this print. Carefully examine the print. If you see a nice, clean, white image with the texture of the original paper showing well, your film development is OK. If you see a white print with virtually no texture showing, your film is overdeveloped. If the print shows good detail but the image is too gray to be of a white subject, the film was underdeveloped.

7 If necessary, do the test again, but change the development time of the film by around 15 percent. Since every photographer has a unique perception, no two people will exactly agree on the results of this visual test. It is important that you obtain a nicely textured, very light tone for a zone VIII exposure.

Zone VIII print too dark, film underdeveloped.

Zone VIII print correct, delicate, white texture feels right.

Zone VIII print too light, white looks overbright and texture begins to be lost.

▶ **Calibrating development**

When development is calibrated, delicately textured light tones are easily achieved. In this image, the lightest areas were placed on zone VIII to retain subtle texture and development was normal. The skin tone is on zone VI½, while the background is approximately zone II.

Effects of development changes on one film

This chart shows the effect of various developments on an image. The middle curve represents normal exposure and development. The other curves represent development changes using zone VIII as the reference point, e.g. the N+1 curve shows a zone VII exposure developed so that it becomes a zone VIII value in the image. This would be seen as an increase in contrast. The other curves show similar results.

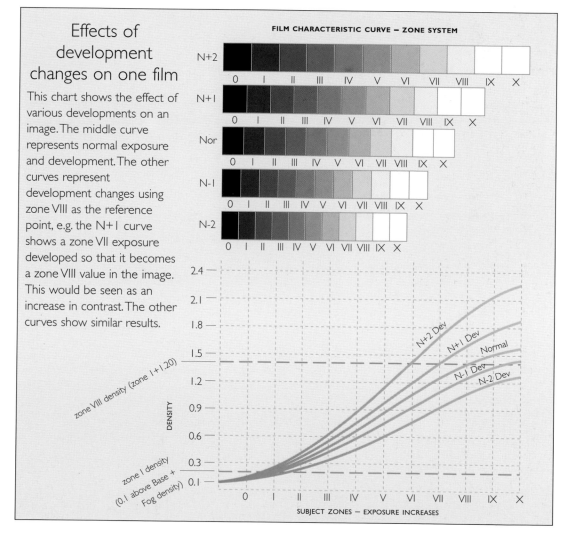

FILM CHARACTERISTIC CURVE – ZONE SYSTEM

Using the zone system with 35mm

Many people believe that the zone system is not useable with 35mm cameras. This is most definitely not the case. The principles and methods of the system hold true for all camera systems. However, you do need to adapt the system to the camera format you are using.

The most obvious limitation for 35mm is that you have 24 or 36 images on one roll. Normally, the entire roll is developed at the same time for one development time. It would seem that this removes one of the biggest advantages of the system, development modification on an image-by-image basis as with sheet film cameras. However, this can be overcome.

One solution is to use three camera bodies with the same film in each. Each body is then labelled as Normal, N+1, or N-1, to indicate the development that film will receive. When you have assessed the SBR of a subject and determined the development required, you simply select the corresponding camera body to use. This way, all the subjects on each roll require the development indicated by the label.

If you only have one camera body or prefer to use more than one film, the recommended method is to always develop your film with reduced development of N-1. This is because it is very easy to increase contrast when printing using paper contrast changes, so a softer negative is easier to print. In addition, the reduced development prevents the light subject zones from blocking up, and allows a wider range of SBR to be shot on the same roll.

Since contrast control in color printing is not as flexible as in monochrome, it is usual to develop color negatives normally. With color reversal film, development changes can be applied effectively as with monochrome film.

▼ **Using a filter**

The zone system was used to assess the exposure. Because this subject was normal, the contrast reduction from the reduced development was balanced by using a higher contrast filter (grade 3½) during printing to bring the image back to what I had visualized.

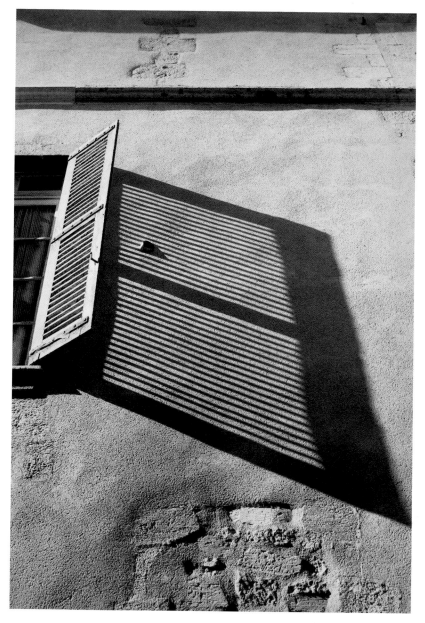

◀ Greater contrast

Here, the subject contrast was more than normal, and the N-1 development of the roll has produced a negative that prints well on normal-contrast paper. The reduced development helped to hold the detail in the sunlit shutter. A meter reading of the light wall was placed on zone VI½ to determine exposure. This is lowered to zone VI during the reduced development.

▶ Normal development

Another contrasty scene, but this time given normal development to retain the bright mood of the grass. The sunlit grass was metered and placed on zone VII.

3 Creative exposure techniques

This section examines how to use the practical aspects of exposure control to achieve the image of the subject that you have visualized.

The "case studies" include analysis of the SBR, choosing the required exposure to achieve the desired tonal rendition, camera settings for depth of field/movement control, tone/color control with filters, and appropriate development changes for contrast control.

The methods are presented as tried-and-tested techniques that will allow you to obtain the result you want with the widest possible range of subject matter.

Visualization

Visualization is the ability to look at a subject and create a mental picture of the final image. This process should take into account the many control options available in the photographic process so that the visualization is translated into an actual picture.

There has been much debate in photography concerning purity of vision, or pre-visualization. The concept that you should always see clearly the exact final image in your mind's eye prior to exposure is a wonderful ideal. However, many photographers feel it is too limiting.

I believe that it is possible to visualize your desired image at the time of exposure, and in fact this visualization will determine how you record the subject on film. However, I also think it valid to explore more than one visualization of the same subject to give yourself options along the creative road to a final image. Even the great Ansel Adams actively encouraged exploration of the visual possibilities through fine printing.

Visualization is enhanced by technical knowledge – the more you know, the more options there are to explore. The challenge is to obtain a final image which contains the emotion and excitement that attracted you to the subject in the first instance. This is only possible if your negatives contain the desired information.

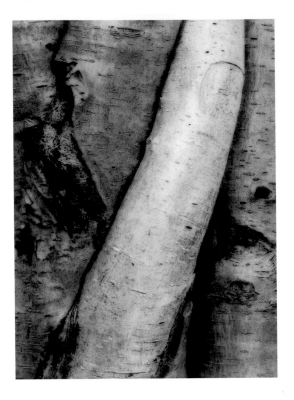

▲ **Dark and light**
This silvery tree trunk attracted me, and I immediately visualized the central trunk surrounded by dark. To add a sense of mystery, I softened the image during printing to spread the dark tones.

◀ **Capturing size**
I was attracted by the immensity of this dam and wanted to include as much as possible. Using a 37mm fisheye on 120 film and including the rail created this abstract.

PRACTICAL TASK

You can practice visualization using the practice sheet provided on page 121.

1 Draw a rough sketch of a real scene you want to visualize.

2 Use your meter to take readings from several areas of the scene, and record them on the sketch.

3 Use the zone scale to place one of the readings on the desired zone for a natural rendition with normal development.

4 Determine which zones the other readings will fall on, and enter them on the scale.

5 Try to imagine how the subject will look as an image. Which areas have detail? How light or dark will each area be in the image?

6 Now imagine alternative renditions based on using different zone placements and development changes. Also, try to visualize the effect of using other controls to alter the tonal balance.

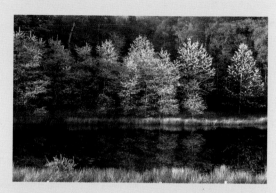

Original scene
The original scene to be photographed, showing viewpoint and composition.

VISUALIZATION PRACTICE SHEET

Subject: trees and pond at sunset

far trees f/5.6½

f/11

shadows f/8

bright trees f/22 f/32

f/32

Metered using shutter speed ⅟30th

water f/5.6 (f/4) reflections f/8 water

f/16 f/16½ sunny grass

Final image tone

0 I II III IV V VI VII VIII IX X

Rough sketch
A rough sketch on a practice sheet, showing important areas together with the meter readings obtained. The shutter speed was set at ⅓₀th second, and the apertures were then used to analyze the scene as shown.

VISUALIZATION PRACTICE SHEET

far trees f/5.6½

f/11

shadows f/8

bright trees f/22 f/32

f/32

Normal dev.

Polarizer to remove minor reflection (and darken)

water f/5.6 (f/4) reflections f/8 water

Actual exposure ¼ sec f/22 with pola.

f/16 f/16½ sunny grass

water darkened by pola to f/4 f/5.6 f/5.8 f/11 f/16 f/22 f/32 white trees in sun

Final image tone

0 I II III IV V VI VII VIII IX X

Final visualization
The final sketch, showing one interpretation of the scene with notes on how the image is to be achieved. The notes include filter used, intended development of the film, and what the final exposure settings will be. The final aperture used is based on the required depth of field.

Using shutters and apertures creatively

Although in terms of exposure control the shutter and aperture of the camera have specific tasks, controlling the amount of light reaching the film is only one aspect of their function. Each control also has a very important role to play on the visual aspects of the image.

One of the most important visual decisions a photographer has to make is how much of the subject should be sharp. The amount of the subject that is acceptably sharp in the image is called the depth of field. Depth of field is controlled by the lens focal length, the distance from camera to subject, and the aperture used on the lens. Once the actual exposure for a subject has been determined, the photographer has a choice of pairs of shutter speed and f/stop that can be used to obtain this exposure. Which f/stop to use should be based on how much depth of field you want in the subject. On older SLR cameras, the depth of field can be determined using the depth of field scale around the lens. Unfortunately, many modern cameras do not have this essential feature, so you will need to use depth of field tables. These are normally to be found in the camera instruction book.

The shutter speeds provide another creative option for how the image will appear. Shutter speeds are used to creatively control any movement in a scene. Blur can be introduced using slower shutter speeds, or movement can be frozen with fast shutter speeds. The degree of blur at any given shutter speed depends on the speed, direction, and distance of the movement relative to the camera. Movement from side to side records more than from back to front at any given speed. The amount of blur can only be established by practice and experience.

▼ **Differential focus**

Differential focus is the term given to reducing the sharpness to isolate a particular part of the subject. Usually, this means a sharp subject against an out-of-focus background. However, here I have reversed this normal method to produce an abstract image.

▶ Slow shutter speed

There are various ways of using the shutter speeds to depict movement. This image of feeding swans shows the simplest, using a long shutter time. The swans were moving at different speeds, so each has a different amount of blur. The shutter speed used was ¼ second. The inclusion of static areas – the wood jetty – helps to emphasize the movement.

▼ Moving the camera

One way to create blur with a static subject is to move the camera during a long exposure time. This slightly abstract image of a pink gate in a field was created by using electronic flash with a slow shutter speed in daylight. During the ½ second exposure time, I moved the camera up and down to blur the gate in the vertical direction. Because the flash fired at the start of this exposure, it produced a combined sharp and blurred image.

Case Study: Normal SBR subjects

As previously discussed, normal SBR subjects contain the desired detail within the texture range of the zone scale (zone II to zone VIII). By definition, the film will require "normal" development to achieve the desired negative values. The image shown here is of just such a subject. My brother and I had gone out on a cold morning to photograph the area known as the Peak District in England. We were both equipped with our Zone VI 5 × 4 cameras and tripods. After climbing up a steep hill, we were met by a freezing wind and iced pools of water. I immediately became excited by the abstract designs in the ice and spent a happy time searching for a picture. I always use a viewing card when looking for compositions, because it allows one to concentrate purely on visual matters (see pages 120–121).

I spotted this design and set up the 5 × 4 almost directly above. I knew from the viewing card that my 210mm lens would be needed, and fitted it to the camera.

After carefully positioning the camera it was time to explore the brightness values with my spot meter. I visualized the image as quite graphic, and hence wanted good dark tones offsetting the lighter shapes. A reading from the dark area was placed on zone II for minimal texture and depth. The reading from the lightest ice fell nicely at the higher end of zone VII. This meant the lightest areas would retain good detail with normal development. Because the subject was essentially flat, only moderate depth of field was required, and this allowed a reasonably fast shutter speed. This was useful because it was breezy, and camera shake was a danger.

All that was left to do was check the focus, set the controls, and make the exposure on Kodak Tri-X film, which I needed to rate at ISO160. This was later developed in Kodak HC110 1+31 for my normal time. This film produces smooth tones with good sharpness, and the negative prints very easily on grade 2 paper.

◀ **Iced pool**
An alternative composition from the same session as the image opposite. The technique used was exactly the same for both images.

▶ **Normal brightness**
With correct technique and a calibrated film speed and development, normal brightness range subjects produce beautiful negatives that are easy to print.

Case Study: Short SBR and normal development

The interpretation you place on a particular scene depends on the mood you wish to create. It is not always necessary or desirable to alter the image contrast of a subject that does not have a normal SBR (see pages 56–57). When faced with a short SBR, lower than normal brightness range (see pages 58–59), you need to carefully consider the type of image you want.

I went to these woods on a bright but overcast day. The air was dead still, and the woods had a very peaceful feeling to them. I decided to make an image that reflected this quietness and feeling of peace. Wandering around with my 35mm viewing card, I selected this view.

The composition was made quiet and peaceful to reflect my mood and reaction to the trees. By arranging the main tree in the

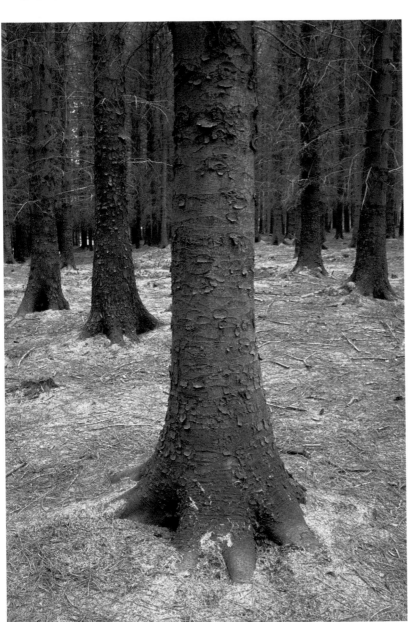

◀ Short range subjects
A short-range subject of three zones given normal development. Accurate exposure assessment is still required to permit choosing the right level of exposure for the desired mood.

Here, the dark areas were placed on zone III½, and the lightest area fell on zone VI½. This exposure placement, together with an 81B warm filter, captured the peaceful mood.

middle, the image is balanced and calm. This is enhanced by including two other trees on either side in an almost symmetrical design. The symmetry is slightly broken by the difference in distance of the pairs of trees, resulting in their bases being at different heights in the image. Finally, the space between the trees adds to the general feeling of solitude and tranquillity.

When faced with a short-range subject that you intend to develop normally, you have a choice of exposures that you can make without losing detail in the important areas. Because the SBR is less than normal, you can select an exposure that reflects the mood you are creating. Less exposure darkens the image, and this can produce a somber or mysterious mood. More exposure lightens the image, and can create a bright mood in the image.

The amount of exposure change available is determined by the difference in the SBR from normal. For example, a subject with a SBR of three zones is not using the full texture range of the film (usually five zones), so the exposure can be reduced or increased without loss of detail to control the mood you want. A three-zone SBR actually uses four zones of the zone scale (remember, the SBR is the difference in brightness between two areas of the subject), so placing the darkest area on zone III means the other subject areas must fall on zones IV, V, and VI. Alternatively, if you place the darkest area on zone V, the other areas must now fall on zones VI, VII, and VIII. This shows that in this example you can adjust the exposure by up to two stops without losing detail, but the mood of the image will be different in each case.

For the final image shown here, I chose an exposure that would retain the quiet mood of the scene. The image was made using a 35mm lens on 35mm transparency film. The camera was tripod-mounted, and the depth of field scale was used to determine the optimum aperture for full sharpness. With an 81B warm filter to counteract the coolness of the light, the exposure was 10 seconds at f/16.

▶ **Unmodified image**
The normal scene exposed as for the main picture, but without filtration and based on retaining full detail throughout.

▶ **Increased exposure**
This image received one stop more exposure than the main picture. This has lightened all the zones equally without losing detail in the lightest areas. This image uses zones IV½ to VII½. The mood has changed, with the woods now looking more open and bright. Notice that some loss of color saturation has occurred due to the extra exposure.

▶ **Reduced exposure**
This image received one stop less exposure than the main picture. This has produced a more somber mood. The image is now using zones II½ to V½. The woods now look and feel less inviting. Color saturation is increased in some areas.

Case Study: Long SBR and normal development

When the range of subject brightness values falls outside the texture range of the film, it is a long-SBR subject. As with short-range subjects, it is not always essential to change overall image contrast. Everything depends on your intention and what you consider important to the image. Long-SBR subjects given normal development usually display either dark shadows or featureless high values, depending on the amount of exposure given to the film. However, it is usually better to retain high value detail and allow shadows to merge to black, which can produce dramatic images. An essential point to note with long SBR subjects is that exposure is critical! There is no room for "latitude" as with short-range subjects.

The dramatic image opposite of a ram figure directly against the sun and clouds is typical of the kind of situation where it may be possible to use normal development. I visualized full, but dramatic detail in the clouds, with the figure and buildings holding subtle detail. This was made possible by the buildings being white. Had the buildings been dark stone, they would probably have simply been featureless black. Light from a building to the left (out of picture) reflected enough light back on to the ram to retain detail.

Using a spot meter, the exposure was based on the clouds close to the sun around the ram's head. A meter check on the buildings showed

Using filters to reduce contrast

Many times a landscape scene has a normal range foreground but with a too-bright sky. Instead of using development to reduce the overall contrast, it is possible to use filters.

This sequence shows a typical subject, where the right half of the sky is too bright to hold detail when the exposure for the foreground is correct. Using a polarizing filter alone darkened the blue in the sky, but not the white clouds. In this case, a graduated neutral gray filter was also used to hold detail in the sky. This was possible because the horizon line is almost straight.

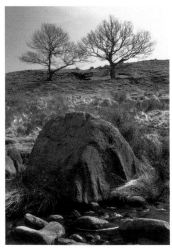

Mild sky correction
The normal scene with polarizing filter only.

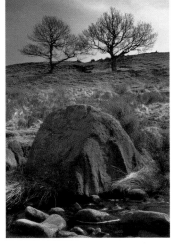

Improved sky tones
 Adding a G1 graduated filter darkens just the sky, producing a pleasing effect.

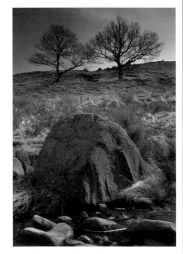

Over-corrected sky
Using a G2 graduated filter with the polarizing filter has produced a dark, somber sky that, in this case, I feel is too heavy in tone.

detail would be retained. The image was made with a 35mm lens on 35mm Kodak Tri-X film. The film was rated at EI (exposure index) of 160, and was developed normally in Kodak HC110 1+31 at 68°F (20°C) for 6½ minutes.

▼ **Zonal range**

The white edge of the cloud near the sun was metered and placed on zone VIII½ to just hold texture. A reading from the building wall indicated it would fall on zone IV½, while the ram fell on zones II and III.

Choosing the right conditions

One of the most important decisions a photographer can make about an outdoor subject is what conditions are required to achieve the desired image. Obviously, for outdoor work the most unpredictable factor is the weather.

If we are lucky, the subject will be seen in the ideal conditions for the image we want the first time we arrive on the scene. However, it often happens that I see a potential image of a subject in my mind, but the conditions are not right. This is where visualization plays its part. By anticipating how you want a particular subject to look in your image, you can determine the best time and weather conditions to achieve what you want.

It is worth spending time analyzing the potential subject to build up the mental image so that when the time comes to make the picture you know what you want to do. Consider composition, color, texture, lighting, and possible manipulations to arrive at your desired result. Then choose the best time to make the image when the conditions give you what you want. However, even with advanced planning, the image you desire may still elude you!

The images here were made with a 70–210 mm zoom lens on 35mm using Fuji Provia 100F film rated at EI 80.

◀ **Adverse weather conditions**
This image has failed due to the weather conditions. Although the image was made on a bright, sunny day, there was rather a lot of atmospheric haze. The combination of a long lens, haze, and blue sky above has resulted in the subject contrast being lowered and the color saturation reduced. Also, the blue sky has added a blue cast to the haze. Not a successful image.

▶ **Natural sidelighting**
This industrial looking wall benefits from the strong, clear sunshine striking it almost from the side. This has accentuated the texture and color in the scene, producing a strong visual design. The exposure was based on placing the sunlit stone on zone VI with normal development.

◀ Scene in cloud

The same scene, but with the sunlight obscured by a large cloud that removed the shadows and lowered the subject contrast. In this case, the reduced SBR was compensated for by using a one-and-a-half-stop development increase. This time the grass was placed on zone IV½. However, the additional light on the background and increased development has raised its value to zone VI. This resulted in the tree being darker in tone, and hence tending to recede rather than stand out.

▶ Scene in sunlight

As these two images of the same scene show, it is impossible to replace good lighting with technical tricks. This image is the result of beautiful lighting and careful exposure control with normal development. Note how the tree stands out from the background in both tone and color. The sunlit grass was placed on zone V½, the background fell on zone IV.

Changing lighting to modify SBR

In a studio environment, everything is under the control of the photographer. The lighting on the subject can therefore be controlled to achieve exactly the subject brightness range desired. In most cases, this will be to take advantage of the capabilities of the film with normal development.

Out of doors, however, controlling lighting is not so straightforward. With close-up subjects, such as flowers, similar control to that used in a studio can be used. With larger scenes, we are at the mercy of nature. However, this does not mean that we have no control at all.

The most important lighting controls provided by nature are clouds. Clouds can act as reflectors, as diffusers for the sun to control lighting quality, and as lighting gobos (masks used with spotlights to create shadow patterns in a studio). Intelligent use of clouds can help with many landscape subjects.

The images here show how the clouds were used to create shadows on the subject. These shadows have been utilized to control the tonal values of different areas of the scene. The sky was rapidly changing from clear to heavy cloud, and this change allowed me to produce different

◀ **Image 1**
The clouds are starting to cast moody shadows on the field.

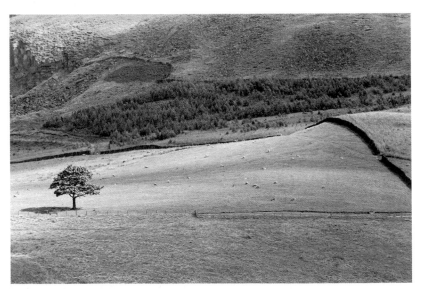

◀ **Image 2**
The clouds are getting heavier and darkening the background with an interesting distribution of light and dark. Not quite the spotlight I wanted, though.

tonal renditions of this simple landscape. My desire was for the tree to be spotlit, and with a little patience this eventually happened.

Using a 210mm zoom on 35mm, I exposed Tri-X rated at EI 160 and developed normally in Kodak HC110 1+31. The exposure was based on the grass in the field. I wanted zone VII around the lit tree, with zone IV or lower for the shadowed areas. Although I could place the zone VII easily, the clouds dictated the tone of the shadows, which were then adjusted in printing.

As illustrated here, this approach often needs lots of patience and lots of film!

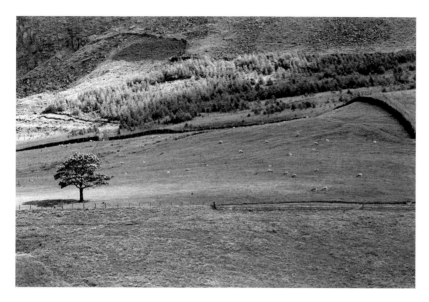

◀ **Image 3**
Aha! My spotlight has arrived! Some useful light on the distant trees adds texture to the background.

▼ **Image 4**
After some additional printing work to adjust the tones and crop of image 3, I have the visualized image.

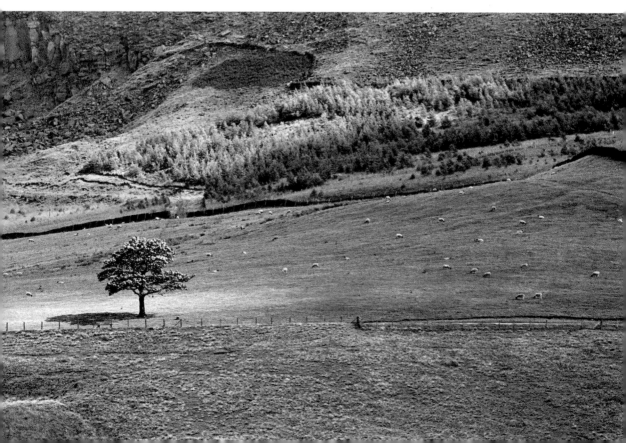

Case Study: Using reflectors

Reflectors are an essential item in every photographic studio to help control lighting and subject contrast. Almost anything that reflects light can be pressed into service to add bounced light to parts of the subject. These are called "additive" reflectors. Black reflectors are also used to darken parts of a subject by "subtracting" light.

When working out of doors on close subjects, reflectors can be very useful for the control of lighting and subject tones. The image shown here was just such a subject. This unusual section of tree bark reminded me of an ear and made me think of the ancient and wise Ents from J. R. R. Tolkien's masterpiece of fantasy *The Lord of the Rings*. I imagined myself in an elven wood and even started chatting to the tree! Funny people, photographers … This method of tone control is simple and effective with white or black fabric.

The tree was just off a clearing in the wood and so was lit mainly from the top right. This produced an uneven balance of tone around the curved trunk which I didn't like. To correct this I used a white reflector to the left of the tree to increase the illumination on that side. A subtractive (black) reflector on the right removed some of the light from the right side of the trunk and increased the sense of top lighting. By adjusting the distance of each reflector from the tree and checking with my spot meter, I was able to obtain the desired effect.

The image was made using a 35mm lens on Fuji Provia 100F developed normally. Spot readings through an 81B filter of the light (zone VI) and dark (zone IV) areas of the "ear" were used to determine the 15 seconds at f/16 exposure. The 81B filter removed the cool cast produced by the overcast conditions.

◀ **Unmodified subject**
The unmodified subject with uneven lighting around the trunk. This needed correcting before the final exposure.

▶ **Modified subject**
Two reflectors and a warm filter resulted in a more balanced tonal rendition. Be careful in the woods, the trees have ears!

Pre-exposure method

Normally, an exposure change on the film affects all image values of a subject by the same amount, so image contrast is unaltered. In-camera pre-exposure (latentsification) is a method of reducing image contrast by increasing the apparent detail of the darker areas of a subject without unduly affecting the lighter areas.

Pre-exposure (or "flashing") is also used in monochrome printing, where it is used to control the light tones of a print.

In-camera pre-exposure is simply a method of exposing the whole frame of film to an even tone value. How much pre-exposure to give depends on how much you wish to lighten the darkest tones. However, too much pre-exposure reduces the depth of tone of the shadows, and the image merely looks fogged.

Fortunately, the zone system gives us a simple way to control the amount of pre-exposure to give. To recap, a zone I exposure is the first exposure that will have a visual effect on the film. Hence, giving the film a zone I pre-exposure will raise the tone of the shadows by a controlled amount. Zone I shadows will double in value and so record as a zone II, zone II shadows will be roughly zone II½, etc. With transparency film, the maximum pre-exposure you can give is approximately zone II exposure. With negative materials, color and black and white, you may be able to use a zone III pre-exposure if the scene is very high contrast, but this is pushing the limits. Too much pre-exposure will show significant loss of shadow depth.

Because pre-exposure affects the shadows of the subject, and development changes mostly affect the high values, the two techniques can be combined to permit selective contrast control of each half of the tone scale.

How to pre-expose

1 Make a pre-exposure device from two pieces of white tracing paper placed in a filter holder as shown in Figure 1.

2 Determine the SBR of the subject by placing the most important light area on the desired zone and then metering the dark areas to determine which zones they fall on. Decide how much pre-exposure is required to lift the dark shadows to the zones you would like them on.

3 Place the device in front of the lens and meter through the device. In Figure 2, the meter indicates a zone V exposure. This exposure needs to be reduced depending upon the level of pre-exposure required. For a zone I pre-exposure, reduce the meter reading by four stops and expose through the device, as shown in Figure 3. For zone II pre-exposure, reduce by three stops. Of course, you can pre-exposure at half zones, e.g. zone I½.

4 Once the pre-exposure is done, remove the device and expose your subject for the light tones (if necessary, remember to set the camera for double-exposure!).

Figure 1

Figure 2

Figure 3

Zone	0	I	II	III	IV	V	VI	VII	VIII	IX	X
Units	0	1	2	4	8	16	32	64	128	256	512
Add zone I pre-exposure	1	1	1	1	1	1	1	1	1	1	1
Total exposure units	1	2	3	5	9	17	33	65	129	257	513
Final image tone	I	II	II½	III¼	IV	V	VI	VII	VIII	IX	X

▲ Zone I pre-exposure

This shows the effect of a zone I pre-exposure on a typical full-range subject. Assuming zone I represents 1 unit of light, each lighter zone doubles the units as shown. Adding a zone I pre-exposure adds 1 unit to each zone. Therefore, zone O becomes a zone I tone, zone I becomes zone II. The other zones change less as they get lighter, until by zone V the change is negligible.

▼ Zone II pre-exposure

A zone II pre-exposure is demonstrated here. Zone II pre-exposure is about the practical limit for transparency film, but with black-and-white film zone III may be possible under certain circumstances.

Zone	0	I	II	III	IV	V	VI	VII	VIII	IX	X
Units	0	1	2	4	8	16	32	64	128	256	512
Add zone II pre-exposure	2	2	2	2	2	2	2	2	2	2	2
Total exposure units	2	3	4	6	10	18	34	66	130	258	514
Final image tone	II	II½	III	III½	IV¼	V	VI	VII	VIII	IX	X

Case Study: Pre-exposure example

These images show pre-exposure in action. It was late afternoon, and this large rock formation had some rather deep shadows that would fall below the textured zone II on the film with normal development.

The sequence of images show the results of applying different amounts of pre-exposure. The final image also shows how the shadow color can be modified by using a filter during the pre-exposure stage, without significantly altering the colors in the main subject. Adding a filter during the pre-exposure can be used to good effect with sunlit snow scenes where the shadows tend to be very blue. (See page101 for information on how filters affect colors.)

Note that there is a definite limit to how much pre-exposure you can apply before loss of image quality is apparent. Also, pre-exposure is a way of making the film appear more sensitive, so you may have to slightly lower the placement of the high values for the second main exposure. In the examples shown here, the zone II pre-exposure required approximately one half-zone lower placement of the zones for the main exposure. For example, after pre-exposure, instead of placing the high value on, say, zone VIII place it on zone VII½.

I used a 35mm lens on a 35mm camera with Fuji Provia 100F film. The film development was normal.

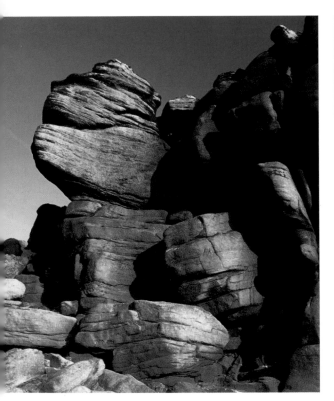

▲ **Straight exposure**

This is the straight exposure based on retaining the values in the sunlit areas of the rocks. The lightest rock in the foreground was a high zone VII (almost reaching zone VIII). The shadows are zone II or lower. The SBR of the scene exceeds the film texture range.

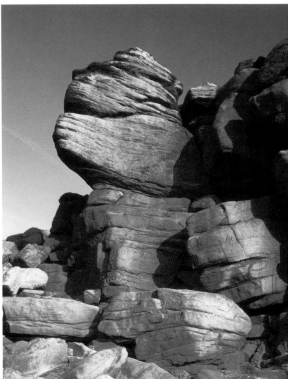

▲ **Zone I pre-exposure**

With a zone I pre-exposure, the shadow values are improved slightly. The pre-exposure has made the emulsion more sensitive by "activating" the light sensitive halides. Note also a slight increase in value of the light rock in the foreground due to the pre-exposure.

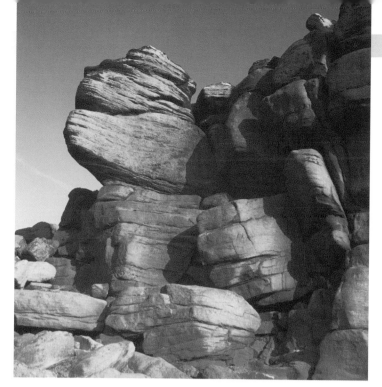

▲ Zone III
pre-exposure

With a zone III pre-exposure, we see a significant loss of image quality. This has now gone too far for this subject.

▼ Zone II
pre-exposure

The final image required a zone II pre-exposure, using an 81A filter to add warmth to the shadow values. The main exposure placement for the foreground light rock was also slightly lower than previously at the lower end of zone VII.

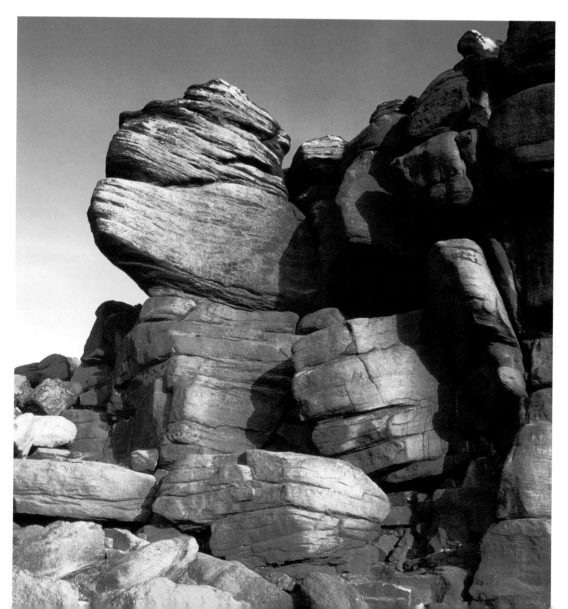

Case Study: Darkroom printing and visualization

Subject brightness control initially takes place at the camera and film-development stages. Once the film is processed it can be printed, and this is where the great majority of photographers undertake tone control. Tone control in the darkroom can take many forms, but the first step is determining the print exposure and paper contrast for a particular image. The print exposure determines the tone of the light areas of the subject, while the contrast of the paper determines the tone of the shadows. It is this latter step that can easily be linked to visualization at the camera stage.

Black-and-white printing papers are available with different contrast ranges. It is relatively easy to calibrate the paper contrast to the zone scale using a set of personal master zone negatives and grade 2 master zone prints. A master zone negative/print set is made by exposing a textured surface on film using zones O to X (11 negatives in total), followed by normal development. A 5 × 4-inch print is made at grade 2 contrast from each negative using the same exposure time. This time is determined by printing the master zone V negative to obtain a print tone that matches a Kodak gray card.

Once the grade 2 prints are done, the master zone negatives can then be printed again on each of the other grades, but using a print exposure time found by printing the master zone VIII negative on the new grade so that its tone matches the grade 2 master zone VIII print. In this way, a set of prints from the same negatives is produced for each grade of paper contrast.

By comparing the print tone and detail of the zone prints on each grade against the reference prints on grade 2, you can determine how much each paper grade changes the normal grade 2 tones. For example, if the print tone and detail of a grade 4 zone IV print looks the same as a grade 2 master zone III print, we can say that grade 4 produces exactly an N+1 (normal plus one) increase in the original SBR of the scene, i.e. a shadow exposed on zone IV

in the subject but printed on grade 4 will reproduce in the print as a zone III—it has been darkened by one zone.

By calibrating each paper grade and assigning N+ (N plus) or N- (N minus) values to the grade, we can utilize this information at the camera stage when assessing a subject. For example, if the subject has a four-zone SBR and you want it to be five zones in the image, you could give the film N+1 development. Alternatively, give the film normal development and make a note to print on N+1 paper. If the example subject had a three-zone SBR, this

Image 1
A normal print using grade 2 paper contrast.

Image 2
A softer print using the same negative but grade 1 contrast paper. Note the shadows are lighter.

Image 3
A more aggressive print using grade 4 contrast paper. Note the loss of shadow information as the tones get darker.

Image 4
Normal print contrast, but this time with a soft filter over the enlarger lens to spread the dark tones. This adds an eerie effect to the image.

could be increased in two stages, N+1 film development and N+1 paper grade.

This system is particularly helpful with roll film (35mm and 120) where you may have different SBR subjects on the same roll. Develop the film N-1 to preserve high value detail, and use paper grades to control shadow values in printing.

The image shown here was made one cold fall morning using a Zone VI 5 × 4 with 120mm lens. Shot on Kodak Tri-X and developed in Kodak HC110 1+31.

▼ **Image 5**

Same as image 4, but with a blue tone to emphasize the coolness of the frost-covered bags.

Case Study: Contrast filters for monochrome

It always surprises me how few black-and-white photographers use filters regularly when making pictures. Contrast filters are most often used to darken a blue sky, but this is not their main function. The real purpose of contrast filters is to allow adjustment of the tonal relationship of the colors in a scene. This can provide important creative options, and whether or not to use a particular filter should be considered for every picture you make.

The images shown here demonstrate the use of contrast filters for tone control. The subject is the Three Sisters in Glen Coe, Scotland, in late October. The weather was turning nasty and heavy clouds were pouring in, producing some dramatic skies. However, the sky was also very bright compared to the mountains, so careful exposure assessment was called for.

I used my Zone VI 5 x 4 camera fitted with a 210mm lens. Because the grass at this time of

▶ **Unfiltered scene**
This is the unfiltered scene. The tonal range of the ground is not very strong.

▼ **Filtered scene**
The orange filter has lightened the grass and darkened the shadows, increasing the tonal range of the ground.

▶ **Alternative filtered scene**
An alternative view using the same technique to lighten the grass. In this case, some blue sky was also visible so the filter has increased the separation of the sky.

year has a golden color, I decided that more local contrast in the land could be achieved with the use of a warm filter. A warm filter color would lighten the areas of grass but also darken the shadow areas, which contained more blue light. This would produce a useful increase in the contrast on the mountains, to increase the effect of the delicate lighting for a stronger result.

By metering different areas of the subject with and without a filter in place on the meter, you can check how much difference that filter is making to the local tonal range. This is the method I used to decide on an orange filter to achieve the amount of tonal change I wanted. Do not assume that you always need this or that filter, check with the meter. To determine the exposure, I metered through the filter with my spot meter. This is the only way to accurately use filters, because filter factors do not work correctly in all situations. See page 38 for advice on using this metering method with filters and how to adjust the readings. The image was made on Kodak Tri-X rated at EI 125, developed normally in Kodak HC110 1+31.

How filters affect colors		
Filter color	Lightens	Darkens
Yellow	Yellow, green, red	Blue
Orange	Orange, red, yellow	Blue
Green	Yellow, green	Blue, red
Blue	Blue	Yellow, red, orange, green
Red	Red, orange	Blue, green

Case Study: Polarizing filter for tone control

Although tone control with filters is easy in black and white, what about color? The filter you need is the polarizing filter. Many think a polarizing filter is only used for darkening a blue sky and removing reflections from glass windows. However, this is only part of the story.

Everything reflects light, and most things produce some specular reflection – the effect that makes objects look glossy or shiny. A polarizing filter can control specular reflection.

The examples shown here demonstrate the use of a polarizing filter to adjust the tonal values of the subject. The pond plants show one of the more obvious types of subject where the polarizing filter can be utilized to control the amount of reflection from the subject. Be careful with this type of subject – it is not always a good idea to eliminate the reflections totally. Retaining a little specular reflection will help to make the subject look more realistic.

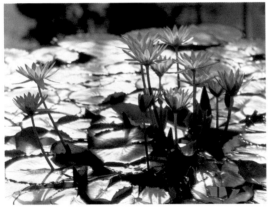

▲ **Unfiltered pond**
This is the scene unfiltered. The tonal balance is not very good, and the reflections are too dominating.

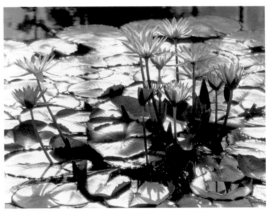

▲ **Minimum polarization**
Using a polarizing filter with minimum effect has toned down the reflections, but they are still too dominant.

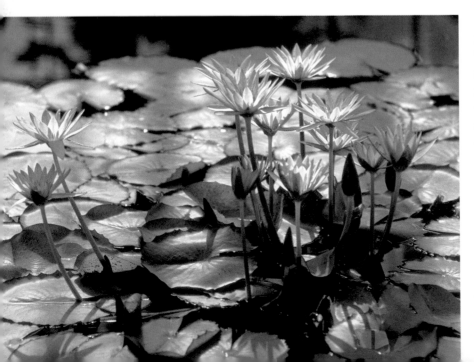

◀ **Maximum polarization**
The final image with almost maximum polarization. Notice the improvement in color rendition, and how the flowers are now more prominent.

The twisted tree image shows a more subtle, but effective use of the same technique. In this case, I wanted the shadowed tree trunk to be full of detail, and so placed it on zone IV. My meter then indicated that the background grass would fall between zone VII and zone VIII, which I decided was too light. By using the polarizing filter to remove most of the specular reflection from the background grass, the grass has been lowered in value to zone VI½ while maintaining the zone IV placement of the tree. The exposure was again achieved by metering through the filter to determine an accurate result. Remember that as the polarizing filter changes the specular reflection of a subject, its zone value will also change, so the meter must be used to check the values.

The amount of control offered by a polarizing filter depends on the angle of reflection of the light from the subject. If you use the filter on a blue sky with the sun at your side the sky will darken unevenly.

These images were made with a 35mm camera using Fuji Provia 100F film developed normally.

▼ **Unfiltered tree trunk**
This is the unfiltered scene. The tree trunk is on zone IV, but areas of the background are too high in value.

▶ **Filtered tree trunk**
The corrected image using a polarizing filter. The background has been lowered in value to bring it within range for good detail.

Development modification

Normal development produces image values that correspond to the exposure zones: a zone VI exposure, for example, produces a zone VI image value. Development modification is a powerful technique used to change this normal relationship between exposure zones and image values.

Often, we use development changes simply to produce an image that looks or prints better. At other times, these changes are used to completely distort the tonal range of the original subject to produce an image that is nothing like the original.

The method is quite simple: expose your subject for the lower zones (shadows), and adjust development to move the higher zones up or down to obtain the required image tone. Generally, zone VIII is used as the "pivot point" for development modification, but you can actually use any zone you wish to work with. Zone VIII is normally used because it is the lightest fully textured high value

and requires the least change to the development time.

If you remember that development is not linear in the way it affects different zones of exposure, it should be clear that increasing development to make a zone VII into a zone VIII (N+1 development) does not raise all the other darker zones by the same amount (one zone). Adjusting a subject zone VII to an image zone VIII is defined as a N+1 increase in development, and will require a specific amount of increase to the development time. However, changing a subject zone VI to image zone VII is also defined as N+1 development, but the change required to the development time will be more. Raising a zone VI to image zone VIII is N+2 development. Conversely, light zones can be darkened by reducing the amount of development. Lowering a zone IX exposure to a zone VIII image value is defined as N-1 development. Again, the effect on the other zones is not linear.

PRACTICAL TASK

Determining the film development times required for N+1, N-1, etc. is similar to determining normal film development. However, this time you expose for one zone and develop until it visually matches another.

1 It is useful to have a reference to work to based on normal development. Using a piece of neutral card, make a master set of negatives/transparencies by exposing the card in soft light on each zone of the scale from zone I to zone X, and develop the film at your optimized normal time. (See Practical task, pages 72–3.)

2 To determine N plus times, use new film of the same type and make separate exposures of the card at zone V, VI, VII, and VIII. When ready, develop the film for 30 percent more time than normal. Fix, wash, and dry as usual.

3 Compare the zone VII frame with the zone VIII frame of the master set. If they are the same, then you have N+1 development. If not, decide whether you need more or less development, and re-test.

4 To find N minus development, expose the card at zones VII, VIII, IX, and X. Reduce the normal

development time by 20 per cent for the first test.

5 Compare the zone IX exposure with your master set zone VIII. If identical, you have N-1 development. If not, re-test with a different development time.

6 For other development changes, simply use the appropriate exposure zone and compare with the relevant master set. There are limits to how much development change can be applied, N+1, N-1, are usually fine. As N-2 often has too much adverse affect on an image, use a two-bath developer process for greater control.

Development changes chart

Use this chart to assist in visualizing the way development changes work when conducting the tests. Think of N+ development as expanding the tone range and N– as compressing it.

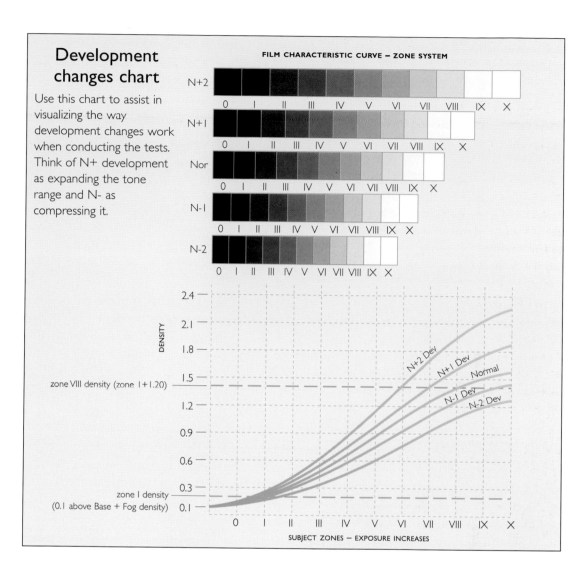

FILM CHARACTERISTIC CURVE – ZONE SYSTEM

▶ **Sample table**

Once your tests are complete, you can make a table similar to this one for your darkroom wall. You will need a different table for each film/developer combination you use.

FP4+5x4 @ EI 80 Kodak HC110 1+11 Tray development					
	N-2	N-1	N	N+1	N+2
X–VIII	5¾ mins				
IX–VIII		6½ mins			
VIII–VIII			7 mins		
VII–VIII				8¾ mins	
VI–VIII					13 mins

Case Study: Increasing contrast

There will be many occasions when you arrive at a location only to find the lighting conditions less than ideal. When the lighting on a scene is flat and even, such as on an overcast day, it usually follows that the SBR is lower than normal. In addition, overcast conditions generally produce less saturated colors and a cool overall image color.

The easiest way to overcome these visual problems is to change the color balance of the image with a filter on the camera lens, and to increase the image contrast with increased development of the film (see pages 104–105).

The simple landscape scene shown here utilizes these techniques to produce a more acceptable final image. However, this method does not give the same final image as a change in the actual subject lighting would, as can be seen by comparing the final images. Better lighting is often a more desirable option.

The images were made using a 70–210mm zoom lens at 150mm on 35mm. The film used was Fuji Provia 100F rated at EI 80.

▼ Using a filter

This image shows how by applying a 81B warm filter the coolness has been removed. Also, by reducing the zone placement of the subject by one zone and increasing development by plus one and a half stops, the image contrast has been increased. The image is now almost what I had visualized. However, this hasn't altered the actual lighting on the subject.

▼ Straight scene

When I arrived at this location, the sky was mostly obscured by quite thick cloud, resulting in almost shadowless lighting. This lighting also dulled the colors in the scene. However, in my mind I saw the warmth of the high grasses contrasted by the green in the field, with the rocks providing textural contrast. The scene has lower than normal SBR. A spot meter reading of the green grass next to the middle rock was placed on zone V and normal development given.

▶ Sunlit scene

This image shows the difference a change in the lighting has made. The sunlight increased the SBR to the point where normal exposure and development provided the desired image. Again, the green grass was placed on zone V. It is worth studying the differences between these three images.

Case Study: Reducing contrast

When faced with a long SBR scene, one of the methods for reducing the contrast range in the image is reducing the development of the film. Since development has proportionally more effect on the higher zones than on the lower zones, reducing development lowers the value of the higher zones in the image. The images shown here demonstrate this technique.

I often prefer scenes when they are backlit (contre-jour), such as the one shown here. However, this inevitably means that I am faced with long-SBR subjects and the problem of controlling the contrast. In this case, I decided to use reduced development of the film to allow a higher placement for the shadows in the foreground grass clump, but at the same time hold the detail in the distant lake. Because the green grass was creating specular reflections, I also decided to use a polarizing filter to control this reflection.

The shadow in the foreground grass was metered and placed on zone IV for full detail. The sunlit grass then fell on zone VII½, and the light areas on the lake fell on zone IX.

Metering through the polarizing filter to check the values showed that the green grass had been lowered in value to zone V½, and the shadows lowered to zone III½. Setting the new meter reading to again place the shadowed clump on zone IV, the green grass now fell on

▲ **Straight scene**
The normal subject without modification. The exposure was based on the light zones to retain detail, but the green grass has lost saturation due to specular reflection. The specular reflection can be controlled with a polarizing filter.

▲ **With polarizing filter**
Normal development and a polarizing filter with the exposure based on the light zones. The shadowed grass is too dark, but the image has good impact due to the high contrast. This image would be acceptable but I wanted more detail.

zone VI and the lake remained on zone IX (the polarizing angle of the green grass and lake were different, so the filter had little effect on the lake). Reduced development of N-1 was called for to lower the value of the lake to zone VIII to maintain detail. Note that development changes also affect the local contrast — in this case, the grass field appears with less inherent contrast on the reduced development images.

The images were made with a 35mm lens on a 35mm camera using Fuji Provia 100F film.

▶ **Reduced contrast, no filter**
Using N-1 development without the polarizing filter. The grass has lost saturation due to specular reflections.

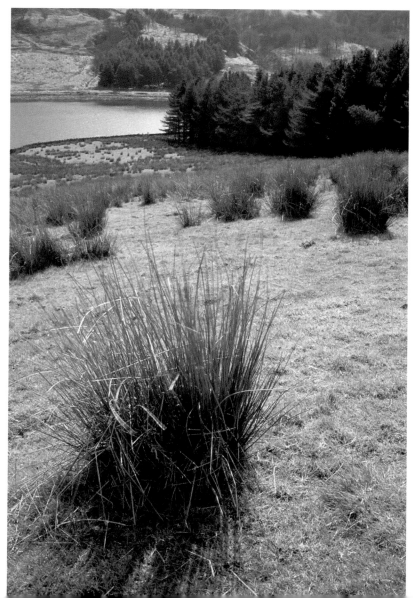

◀ **Reduced contrast with filter**
The final image, with good color saturation in the green grass and better control of the tonal range.

Case Study: Local tone control

Most of the preceding sections have discussed the techniques associated with manipulation of the technical aspects of exposure control. However, there will be occasions when it is not possible to obtain the desired image in this way. The image shown here is just such a case.

The subject was very appealing, due to the shape of the rocks, the lighting, and color. The image, however, was difficult to compose, because of the river and the location of other rocks. The main problem was the light rocks in the lower left corner. What we have here is a

▶ **Straight scene**
This is the subject without modification. Note the distracting rocks in the lower left corner and the reflection off the water.

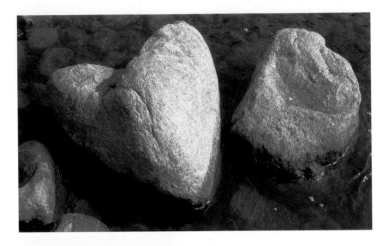

◀ **With filter**
Applying a polarizing filter to remove the water reflections has darkened the background, but not the corner rocks.

▶ **Specular highlights**
With the corner rocks wet, specular highlights became a problem.

subject that needs local control of some of the brightness values. If I had been working with black and white, I would have the option to apply local control when printing, by burning in the offending rocks. However, using color transparency film required the problem be dealt with at the time of exposure.

I considered different options, as shown by the sequence here. My first thought was to reduce the reflections from the water to make the rocks stand out more and increase the bright green color. However, this didn't cure the problem of the corner rocks. My next idea was to splash water onto the rocks to darken their tone. This worked well, but resulted in bright specular highlights that again distracted my eye from the main subject. I decided that the only solution was to somehow shade the corner rocks from the light and make them dark in tone. This would reduce their brightness and

remove the highlights and strong color. Unfortunately, the rocks were out of reach in the river. The solution was to find a fallen branch and hang my jacket from it while stretching it out over the river to create a shadow over just the corner rocks. I also adjusted the polarizing filter to give just a hint of reflection from the water, because removing it entirely made the left side of the image too dark. It is in situations such as this that you are glad to be using a tripod and long cable release. If I fell in my equipment was safe!

This image was made on 35mm with a 100mm lens. The film was Fuji Provia 100F developed normally.

▼ **With filter and shadow**
The final image with the corner shaded to reduce its brightness. The shape of the other rocks is now the main element.

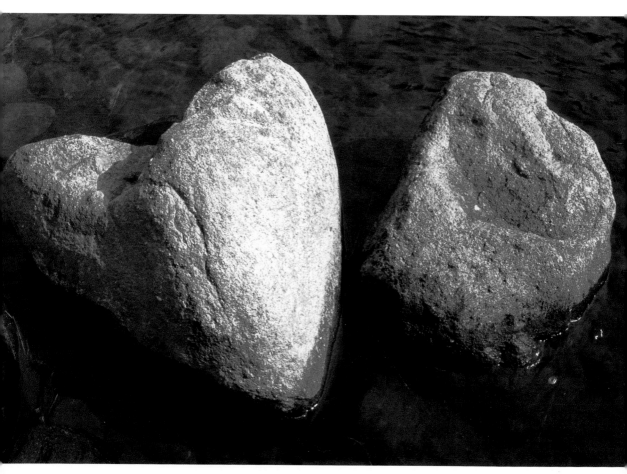

Case Study: Multiple exposure

The subject shown here requires local brightness control on a bigger scale than the previous case. This required a different technique using filter and exposure technique.

The subject was dimly lit, predominantly from windows on the right, with some additional light coming through from the left windows. The distant windows looked out onto a sunlit area and were very bright. My visualization called for good detail inside and out, to avoid blank, white windows looking like white eyes. Also, the main light was being reflected from grass lawns outside the windows, causing a cool color cast in the roof of the room.

The first task was to compose the picture. I used a 35mm lens on a 35mm camera placed low down on a tripod. Next I assessed the SBR and found that the range was from zone I in the arches top left to zone X through the windows.

It was not possible to hold this range with a straight exposure. I decided on a zone II pre-exposure to raise the shadow values. In addition, the uneven lighting from right to left required me to use a graduated gray filter placed vertically in the filter holder. This reduced the brightness values on the right and balanced them with those on the left. This was all checked with the light meter, of course.

This gave me a reasonable image, but I wanted the windows to have more detail. The development of the film would be normal because of other images on the roll, so the only option was to use double exposure. The idea was to expose for the distant windows on zone VII then use black tape stuck to the graduated filter to block both the window areas and expose the interior on the same frame.

▲ **Straight scene**

This was the best result a straight exposure could achieve. The SBR is too long for the film to handle. The uneven lighting is also apparent.

▲ **Pre-exposure and filters**

A zone II pre-exposure, graduated gray filter, and an 81A filter produced a more acceptable result.

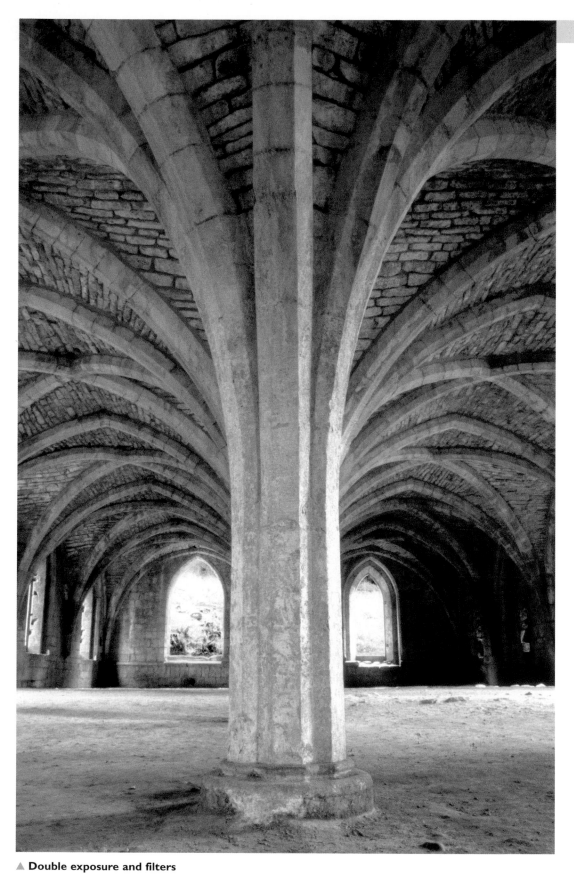

▲ **Double exposure and filters**

Using a double-exposure technique together with
the graduated gray and 81A filters produces the
result I wanted.

Appendices

The following pages provide some useful, easy-to-make devices for understanding and using the zone system, especially with 35mm TTL metering systems; ideas that will help you visualize your subject and improve your ability to isolate compositions within a complicated scene; and practical methods for tests to calibrate your camera system for more accurate results. These methods are based on printing negatives, so some form of simple darkroom is required.

It may take a little practice to fully grasp the methods presented here, but I strongly encourage you to utilize these ideas – my experience suggests that photographers at all levels can gain from them.

Zone scale for lenses

One of the main problems when using the zone system with 35mm cameras and TTL metering is gaining confidence in placing a reading on the relevant zone.

Many people inadvertently increase the exposure when they should be reducing it, and vice versa. For example, when you want to place a shadow on zone III, the exposure indicated needs to be reduced by two stops, not increased by two stops (which would place it on zone VII). In order to assist with this problem, you may be able to add a zone scale directly to each of your lenses (a similar aid can also be added to most hand-held meters).

Lens zone scale

The lens zone scale makes it easy to use TTL meters with the zone system. For camera lenses that have an aperture ring on them, you will notice that the distance between each f/stop on the ring is the same. This allows us to make a zone scale and fix it either in front of, or behind the aperture ring on the non-moving part of the lens. A white self-adhesive label is ideal for making a simple lens zone scale.

To begin with, carefully measure the distance from the center of one aperture number to the center of the next number on the lens. Then use this distance to make a zone scale, as shown in the photographs below and opposite. Take care to note the direction in which the zone numbers are set out on the scale. With the aperture ring set to f/5.6, the higher zone numbers must be on the same side of the lens as f/22. Make certain zone V on the scale lines up with the aperture mark on the lens.

The addition of this simple zone scale to a lens makes it very easy to place TTL readings of a subject on the desired zone. Simply measure a subject area, note the aperture given by the meter, and rotate the aperture ring so that that particular aperture lines up with the zone you want it to be placed on. The camera is then set correctly for the desired exposure.

To check other areas of the subject, take a meter reading (do not change the aperture ring) and look where the aperture falls on the zone scale. You will find that using this scale quickly becomes instinctive and greatly aids visualization and speed of operation.

◀ **Lens zone scale**
Here, we see a zone scale next to the aperture ring on the lens. Note that zone V is aligned with the normal aperture mark on the lens. Also, in this case the f/stop scale runs from left to right as the numbers increase. The zone scale must do the same. If your aperture scale runs right to left, the zones must increase from right to left.

▶ Step 1 - Meter one area

To use the scale, meter an area of the subject and set the camera controls. In the example shown here the meter indicated ½₅₀th second at f/22 for a textured white wall. However, this would produce a zone V exposure.

▶ Step 2 - Place on zone

To correctly place the white wall on zone VIII, rotate the aperture ring until f/22 is opposite zone VIII on your scale. This has increased the exposure by three stops to zone VIII. By metering other areas and noting the f/stop, we can determine which zones they will fall on. For example, any area of the subject that has a meter reading of ½₅₀th seconds at f/11 will be zone VI in the image.

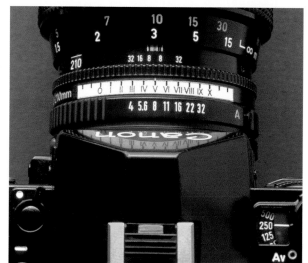

▶ Step 3 - Adjust for DoF

Once the exposure assessment has been done, you may need to adjust the aperture for the depth of field. In this example, closing the aperture to f/16 requires a similar adjustment to the shutter speed to maintain the same level of exposure. Here the shutter speed was changed to ¹⁄₆₀th second. This would ensure the white wall was still on zone VIII.

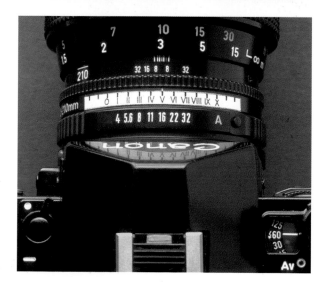

Zone dial for TTL meters

For cameras that do not have an aperture ring on the lens, it is a simple matter to construct a separate zone scale dial. This dial can be used to translate the shutter/aperture information provided by the camera into zone values to assist with visualization. I have provided my own design here for your personal use only.

To make the device, photocopy or redraw the design below. Glue each circular piece to thin card and cut them out. Next, the two rectangular pieces should be glued back to back on the same piece of card to make one item. For a more durable result, you could simply plastic-laminate the pieces.

Once the three parts are ready, fix them together using a paper fastener or the type of plastic stud fastener used in dressmaking. Make sure you attach the circular dials to the appropriate side of the rectangular part.

This dial is slightly more versatile than the lens zone scale alone, because it allows you to use either the aperture or shutter speed to determine zone placement. When working with aperture values, you use the dial in the same

▶ **F/stop dial**

35mm Zone Dial – using aperture (f/stop). Use the f/stop indicated by the arrow.

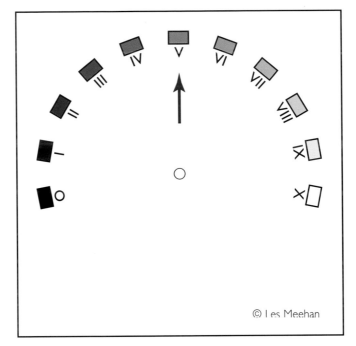

© Les Meehan

▶ **Instructions**

1. Set the shutter speed.

2. Meter subject area.

3. Rotate f/stop to *place* Zone.

4. Check where other areas *fall.*

5. Set f/stop shown below Zone V from dial to camera.

6. Expose.

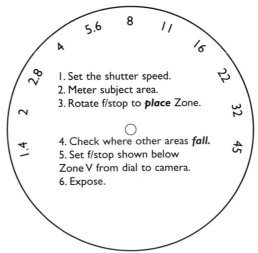

1. Set the shutter speed.
2. Meter subject area.
3. Rotate f/stop to *place* Zone.

4. Check where other areas *fall.*
5. Set f/stop shown below Zone V from dial to camera.
6. Expose.

way as the lens zone scale. Meter a subject area, set this exposure on the camera, then transfer the f/stop value to the dial and rotate to place it on the desired zone (do not move the dial once the first value is placed). Check other areas by determining where their f/stop falls on the scale. The actual f/stop required on the camera is shown below the zone V position.

If you want to use shutter speeds, set the desired f/stop on the camera aperture ring based on the depth of field required, and leave it fixed. Now meter an area of the subject and note the shutter speed given by the meter for your chosen aperture. Using the dial with shutter speeds on it, place this shutter speed on the desired zone (do not move the dial once the first value is placed). Check the shutter speeds indicated for other areas, and determine which zones they fall on. The actual shutter speed to use for the final exposure is shown below the zone V mark. If your camera has both shutter speed and aperture priority modes, you may find both the lens scale (see pages 116–117) and this dial useful.

▶ **Shutter dial**
35mm Zone Dial – using shutter speeds. Use the time indicated by the arrow.

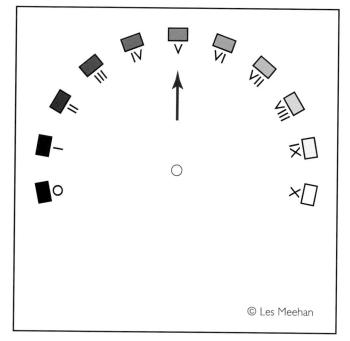

© Les Meehan

▶ **Instructions**

1. Set f/stop required.

2. Meter subject area.

3. Rotate time to **place** Zone.

4. Check where other areas **fall.**

5. Set time shown below Zone V from dial to camera.

6. Expose.

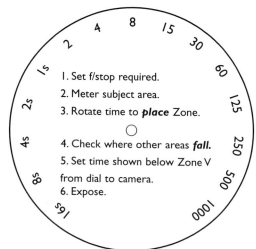

1. Set f/stop required.
2. Meter subject area.
3. Rotate time to **place** Zone.
4. Check where other areas **fall.**
5. Set time shown below Zone V from dial to camera.
6. Expose.

Visualization aids

Like most practical things, the technique of visualization becomes easier the more you practice and experiment. In order to assist with this technique, it is useful to make a viewing card and prepare some exercise sheets as shown on these pages.

Although the viewing card is simply a piece of black card with a rectangular hole in it, I consider it one of the most important items you can use to improve your image creation. A viewing card allows you to explore a subject freely without the encumbrance of cameras and tripods. You will be amazed at how this simple device can improve your compositional skills.

To use the viewing card, hold it in front of and close to one eye. The distance between the card and your eye should be the same as the focal length of the lens you will use for the picture. For example, if the card is 100 mm in front of your eye, the amount of the subject you will see through the hole is similar to what a 100mm lens would see from the same position. Do not hold the card at arm's length unless you have an 800mm lens available!

Because the hole for use with 35mm is only 1 x 1½ inches (24 x 36 mm), I tend to double this size to 2 x 3 inches (48 x 72 mm). In this way, I can hold the card a more comfortable distance from my eye; but remember that the lens focal length required would be only half this distance.

Holding the card steady, move around the subject, exploring the image seen through the hole. Move in all directions, up, down, left, right, forward, and back to examine the various changes that take place within the image. Once you are happy with the view through the card, set up your camera in exactly the same position with a lens of the correct focal length, and fine-tune the image through the camera. You will find this simple device a great time and effort saver when searching for images to make.

Once you have found the composition you wish to make, use the visualization practice sheet shown here to explore the brightness values of the subject and visualize different exposure and development options. If you draw a rough sketch of the subject on the sheet and write on it the various meter readings, you can build up a mental picture of how the scene will translate into a final image. To help visualize the tonal values of the final image, transfer the readings to the desired zones on the zone scale under the sketch.

Practicing with these two simple learning aids will quickly improve your vision and SBR analysis technique.

▲**Viewing card**
Use the viewing card to isolate only the part of a subject you want in your image. The black border removes the distracting parts of the scene and allows you to concentrate on the important area.

▲**View inside the card**
Once the subject area of interest has been found with the card, the camera can be positioned and the appropriate lens chosen with confidence. This is far easier than wrestling with a camera and tripod. Here, we see the final image as seen through the viewing card from the previous picture.

5 in
(125 mm)

2 in (48 mm)

2¾ in (72 mm)

6¼ in (155 mm)

 35mm Viewing card

For other formats, e.g. 6 x 7 cm, make the hole the
same size as the image and allow approximately
1¼–1½ in (30–40 mm) of black border.

▶ **Visualization
practice sheet**
Photocopy this half of
the page to use for
practice. Remember to
include the zone scale.

Final image
tone

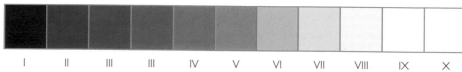

I II III III IV V VI VII VIII IX X

Film speed and development tests

The two most important calibration tests for monochrome photography you should do – if nothing else – are detailed below. The tests are not difficult to do, and should not take much time. However, the difference in the technical quality of your work will be very noticeable. But first a word about negative density measurement.

Negative density measurement

In the calibration tests detailed below, I explain a method of determining results based on darkroom printing rather than exact density measurement (which requires either a densitometer or a spot meter). The human eye has great difficulty distinguishing subtle changes in very dark tones. Therefore, I recommend using printing times derived from density units. A density difference of 0.1 (zone I density) requires a printing time multiplication factor of 1.2599 (the cube root of 2), as used below.

As mentioned earlier, zone VIII is the "pivot point" for film development. To determine the zone VIII values when checking development, I use what I call the zone V method, which is based on using a Kodak gray card as a reference. By exposing a Kodak gray card at zone V on each test, you obtain a known reference tone that can be used to determine printing times for the tests.

Note that all the printing is done on normal-grade paper (e.g. grade 2, or VC filter for grade 2).

Film speed test

The film speed suggested by the manufacturers for their products does not take into account your own personal working methods. In most cases, you will find that you need a lower ISO setting to obtain the best negative quality, so it is necessary to test the film to obtain a personal speed (referred to as your EI or Exposure Index). In this test, we are aiming to obtain a negative density between 0.09 and 0.12 above film base plus fog for a zone I exposure in the camera.

1 Set the meter to the manufacturer's film speed as the starting point.

2 In even light, meter and expose a Kodak gray card at zone V on the first frame.

3 Now expose six more frames in the following order:

Frame 2 at zone I (4 stops less than meter reading)

Frame 3 at zone 1½ (3½ stops less than meter reading)

Frame 4 at zone II (3 stops less than meter reading)

Frame 5 at zone ½ (4½ stops less than meter reading)

Frame 6 at zone 0 (5 stops less than meter reading)

Frame 7 blank, don't expose, just wind on (no exposure represents film base plus fog)

4 Process the film for your usual time at 68° F (20° C). Then fix, wash, and dry.

Assessing film development times

As with film speed, the development times suggested by the manufacturers are not based on your working methods, and will usually tend to be inaccurate. This will lead to negatives that are not what you expected. Once you have established the correct development time for a particular film/developer combination, it should remain the same. If you change the film or developer, it is necessary to do the test again. Each film/developer combination will require a unique development time.

The development calibration can only be done accurately after the film speed test has been completed. Correct development ensures that the higher zones are reproduced accurately on the negative. Too much development and the high zones will lack sufficient detail; too little,

and they will be gray and flat. The correct negative density for a zone VIII exposure depends on the light source of the enlarger you use. For diffuse light enlargers, the zone VIII density should be in the range 1.25–1.35, but for condenser types the range is lower at 1.15–1.25. This is due to the Callier effect, found in condenser enlargers, which has the effect of increasing apparent contrast. This is caused by silver in the negative scattering the parallel rays of light as they pass through the negative. In areas of high density (the bright subject areas), the light loss due to this scatter is more than in the shadow areas, so the image contrast is increased. This effect does not occur with diffuse enlargers, because the light is already fully diffused before reaching the negative.

5 In the darkroom, place the unexposed blank frame 7 in the enlarger set for a 16 × 12-inch print size and produce a small (3 inch square) test print that is a light gray tone. Stop the lens well down and aim for a print time of around 10 seconds (if necessary, raise the enlarger further to obtain a longer time). This is your reference print and time.

6 Without changing the enlarger set-up, multiply your reference print time by 1.2599 (round to one decimal place or whole number, depending on your enlarger timer), and make a test print from each of the test negatives (not the zone V negative) using this new time. The multiplication factor equates to a density value of 0.1. You should now have six test prints. Compare the reference print with each of the test negative prints. The test negative which is closest in tone to the

reference print is the one that tells us the true film speed.

7 Determine the new film speed from the following:

Frame 2 at zone I – use manufacturer's film speed (e.g. ISO 100)

Frame 3 at zone 1½ – reduce film speed by half a stop (e.g. ISO 64)

Frame 4 at zone II – reduce film speed by one stop (e.g. ISO 50)

Frame 5 at zone ½ – increase film speed by half a stop (e.g. ISO 125)

Frame 6 at zone 0 – increase film speed by one stop (e.g. ISO 200)

Normal development

To test for normal development you need a Kodak gray card and something matte white that is lightly textured (I paint the rough side of a piece of hardboard or Masonite matte white).

1 Place the white board and Kodak gray card in even light.

2 Using only the gray card filling the frame, meter it and make one exposure at zone V.

3 Now use the white board in the same light, and meter it. Make a zone VIII exposure by increasing the meter reading by three stops.

4 Use the rest of the film, then develop it at the manufacturers' recommended time and temperature. Fix, wash, and dry the film.

In the darkroom, set the enlarger up as if making a 10 x 8-inch print using the zone V negative. Using a piece of printing paper (about 3 inches square), print the zone V negative so that the tone of gray obtained exactly matches the Kodak gray card. The human eye is very good at comparing mid-to-light tones. Do this carefully, and dry each test before checking with the Kodak gray card. This determines the printing exposure needed for this test.

Once you have an exact match, replace the zone V negative with the zone VIII negative. Do not move the enlarger or change the exposure setting. Make a small print from this negative using the same time as the zone V print, but cover half the paper with card to keep it unexposed. When dry, carefully examine the zone VIII print. If film development is correct, you should see a fairly light-toned, but fully detailed image of the white board. You should be able to see the texture of the board. If you cannot see any difference in tone on the print (or just a hint of tone), your film was overdeveloped. If the board looks to be too dark in tone, the film was underdeveloped.

If required, repeat the test again but change the film development time by 15 percent. Make sure you print the new zone V negative, because a change in development will also make a small change to the zone V negative, and thus a difference to the printing time.

Once you have the development time correct for normal development, keep the zone VIII print to use as a reference when testing for development modifications. For example, to determine normal plus one development (N+1), expose the white target on zone VII and increase development until a print from this negative matches the normal zone VIII reference print. If you record all the enlarger settings and print exposure details, you should be able to quickly repeat the printing. To determine N-1 development, expose the white board on zone IX and reduce development until it prints the same as the normal zone VIII reference print. N+2 and N-2 development are found in the same way, using zone X and zone VI exposures respectively.

The test procedures are easier to do than to read about so don't be put off if it seems complicated. It really is worth the effort and will make your picture quality far better.

Index

Acknowledgments

All books are created by team effort even though the author's name hits the cover. This book is no exception and it would not have been possible without all the team. First and foremost I would like to thank Patricia Meehan, without whom I would not have been a photographer. Also, thanks to Sarah Hoggett for being enthusiastic about the idea for the book and making it happen in the first place. Thanks to the editorial team and senior editor, Clare Churly, for making it come together. I also need to thank Minolta (UK) and Sekonic for the use of the pictures of their respective meters on page 47. Finally, thanks to everyone who buys this book, I hope it helps you and if you want to contact me regarding the book email: lesmeehan@hotmail.com.